STRANGE SITES

UNCOMMON HOMES & GARDENS
OF THE PACIFIC NORTHWEST

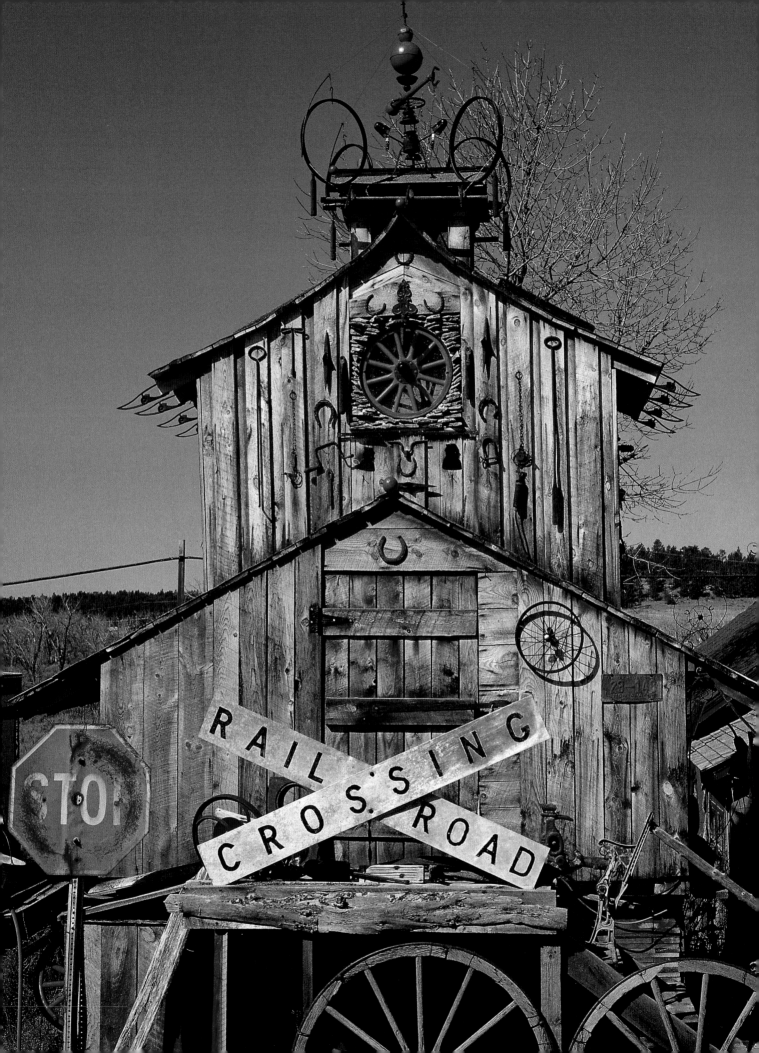

STRANGE SITES

UNCOMMON HOMES & GARDENS
OF THE PACIFIC NORTHWEST

Jim Christy

HARBOUR PUBLISHING

Harbour Publishing
P.O. Box 219
Madeira Park, BC Canada V0N 2H0

Published with the assistance of the Canada Council and the Government of British Columbia, Cultural Services Branch.

Cover design, page design and composition by Roger Handling/Terra Firma Design.
Project photographers: Joe Ferone, Felix Keskula, Lionel Trudel and
Alex Waterhouse-Hayward.

Front cover photograph: The Junk Castle, Whitman County, Washington, created by Victor and Bobbie Moore. Photo by Lionel Trudel.
Frontspiece: Little Mansion, Roundup, Montana, created by Tim Anderson.
Photo by Lionel Trudel.
Pages 6-7: Petersen Rock Garden, Redmond, Oregon, created by Rasmus Petersen.
Photo by Felix Keskula.

Printed and bound in Canada

Photo credits:
Jim Christy 33 (bottom), 72, 73; **Joe Ferone** 10, 24 (bottom), 36 (bottom), 45, 46, 47, 48–49, 54, 55, 61, 65, 76, 77, 78, 79, 80–81; **Felix Keskula** 6–7, 33 (centre), 50, 51, 56, 90, 91, 92–93; **Nicola Lake** 14, 15 (left), 32; **Lionel Trudel** 2–3, 12, 13, 15 (right), 21, 22–23, 27, 28–29, 30, 31, 37, 38–39, 40, 41, 42, 43, 44, 66, 67, 68, 74, 75, 82, 83, 84–85, 86, 87, 88, 89; **Alex Waterhouse-Hayward** 11, 16, 17, 18–19, 20, 24 (top), 25, 34, 35, 36 (top), 52, 53, 60, 62, 63, 64, 69, 70–71, 94; **Yukon Government** 59.

Canadian Cataloguing in Publication Data

Christy, Jim, 1945–
　Strange sites

　ISBN 1–55017–131–3

1. Gardens—Canada, Western. 2. Gardens—Northwest, Pacific. 3. Dwellings—Canada, Western. 4. Dwellings—Northwest, Pacific. I. Title.
SB466.C22W3 1995　　712'.6'09712　　C95–910750-9

For my Mother

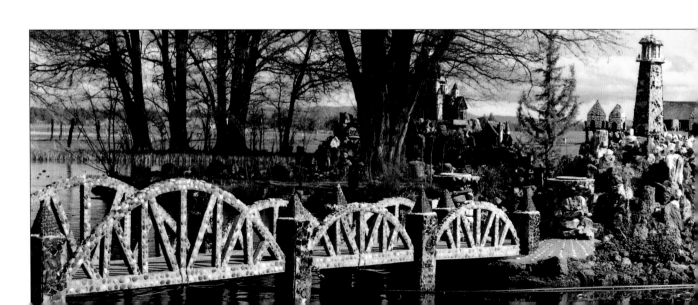

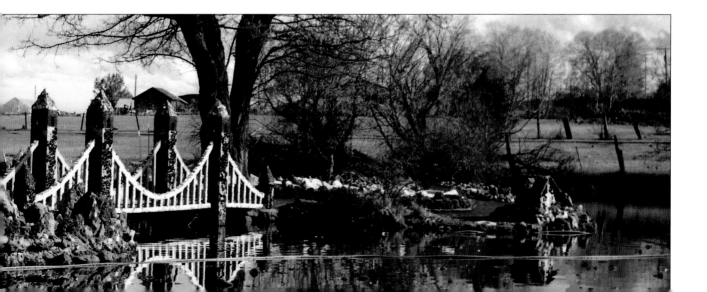

Nobody's Ever Done Anything Like This

For me, this interest in strange sites began with photographs of Clarence Schmidt's thirty-five-room, seven-storey edifice in Woodstock, New York. One picture showed Mr. Schmidt, long white hair and beard, holding one of his assemblages, a self-portrait in a wide frame of tinsel embedded in roofing tar; in the background his outrageous home appeared to spread up the hill into infinity.

Before that, I had known of a few other bizarrely personalized homes and gardens, but I'd never made a real imaginative or empathetic connection. The first eccentric site I had been conscious of was the Watts Towers in Los Angeles. The towers were built of steel, concrete and bits of ceramic tile during the Depression and war years, by a Neapolitan immigrant named Simon Rodia. The tallest tower rises to 99.5 feet. Once labelled a "pile of junk" by a city building inspector, the towers are now on the National Register of Historic Places. They have been given a wide berth in two major riots, and I picture them, tips thrust up through the black smoke of burning liquor stores and police cars.

I was even more fascinated by the Palais Idéal of the French letter carrier, Ferdinand Cheval. One day in 1879, while making his rounds, Cheval found an intriguing odd-shaped stone which he placed in his mail pouch. He found another, and another... For forty years Cheval worked to construct a palace with these stones and reinforced concrete. He encrusted the surfaces with sculpted plants and animals. His garden was made of concrete palm trees. It was

Cheval's desire to be buried in the Palais Idéal, but the authorities informed him that this would not be permitted. So, at age eighty, Cheval began building his own tomb at the public cemetery in Hauterives.

I learned of a couple of other places, such as Ed Leeskalnin's Coral Castle in Homestead, Florida, and the incredible 60-acre rock garden of Nek Chand at Chandigarh, the capital of the Punjab. The look of these places appealed to me as did the stories behind them, yet they remained somehow remote.

The pictures of Schmidt and his place changed all that. "Nobody's ever done anything like this," he said. He was right. Then, when the massive construction burned down, he did it again. When that building burned, Schmidt did, for an incredible third time, what nobody else had ever done.

I was hooked. I suppose it helped that Schmidt reminded me of an old-time hobo called Pop who I'd met near the train yards many years before in Kansas City, Missouri. The hobo camp, which had been there for decades, was at the foot of a hill, below a four-lane highway. On the other side of the highway was a used car lot. When Pop got too old to hop freights, he bought a huge four-door '37 Nash, and had some of the other hobos push it for him, over the highway and down the hill. Where the car came to rest, Pop made his home.

His gear was stowed in the trunk and he cooked his meals under the wings of the upraised hood. Pop slept in the back seat and the front was his living room. He scrounged a few garden gnomes for the roof and made a fence around his place with pickets, thick sticks and a half dozen golf clubs. He'd sit with his buddies cutting up jackpots under an awning that extended from the roof at one side of the Nash. Pop had white hair and a beard like Clarence Schmidt. What Schmidt had done was really an extension of the idea behind Pop's auto home.

It occurred to me that I had always been drawn to this kind of thing. As a kid I was fascinated by wreckers' yards and junk-strewn vacant lots. I liked tool sheds and fishing shacks and tree-houses. Even then, the split-levels and ranch houses, Cape Cods and Colonials that seemed to be everywhere, filled me with despair. But I was intrigued by tumble-down "eyesores" along the river; home, I was told, to weird oldtimers and harmless nuts.

So I began eventually to wonder whether there was anything along this line near where I lived. Somebody mentioned a bottle castle and replica of the Taj Mahal near Duncan, BC, on Vancouver Island, and I went to see it. I met a friend on board the ferry from the mainland and recall feeling a mite awkward when he asked me where I was headed.

George Plumb's buildings whetted my appetite, but I didn't know of any other strange personalized sites. I soon discovered that one does not go into a library or chamber of commerce and emerge with many leads. What one does is get on the road—which is what I did. And have been doing ever since.

At first I worried that I wouldn't find anything, that there weren't any more examples. But soon enough, I realized there is no end to the urge to personalize one's surroundings in ways often outrageous. It is indeed universal. The proof is just around the next bend in the road.

I have a ball finding these places. The technique is simple: I stop people, usually older people, on the street or approach them in coffee shops, usually in small towns. "Anything weird around here?" I ask. "Yards or houses, like that?"

There was the man in the interior of British Columbia. At first I thought he wanted to call the Mounties. "Now let's see," he said instead, rubbing his chin with a big old hand, making a sound like coarse-grade sandpaper on the side of a barn. "There's this couple outside of town a ways. They have four or five hundred of them lawn ornaments in the front yard, bunch of peacocks running around, stuff hanging from the trees. That the kind of thing you're interested in?"

Then there was the time I stopped for gas in Idaho. The cashier looked like an angry Sumo wrestler. When I asked her the usual question, she just stared at me like I was a Communist from New Jersey. Without expression, spitting out each word, she said: "Under the viaduct there. Flying saucers. On the roof. In the yard. Goofy. Pluto. Eleven dollar. Thirty-six cents."

Jim Christy

LAWN ORNAMENT EXTRAVAGANZA

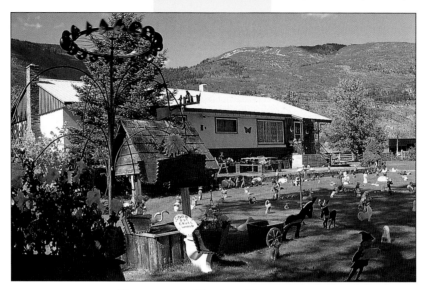

Bert and Gladys Stewart
Salmon Arm, British Columbia

BERT AND GLADYS STEWART LIVE IN SALMON ARM, BC, ON PART OF THE 168-ACRE PROPERTY HOMESTEADED BY BERT'S GRANDFATHER IN THE NINETEENTH CENTURY. THEIR HOUSE OCCUPIES THE SITE OF THE FIRST SCHOOL IN THE SHUSWAP COUNTRY. IT IS ON THIS HISTORIC SPOT THAT THE STEWARTS HAVE ESTABLISHED THE ULTIMATE LAWN ORNAMENT EXTRAVAGANZA.

Scores of ceramic animals, plastic flamingoes, people made of wood, and garden gnomes reside here. Turn your head and when you look back again, you could swear there are more of them.

"Several times people have come by who've moved from houses into apartments and they bring us their stuff," says Bert. "There's always room for more."

"One morning around five o'clock I heard a noise out on the lawn," Gladys recalls. "I looked out the window just in time to see a man tiptoeing between the rows. At first I thought he was going to steal something, then I noticed in his hand was a black ceramic cat. He set it on the ground over there and tiptoed back to his car and drove off."

Not content with recycling ornaments, Bert has made plenty of his own. As well, he builds windmills, whirligigs and wooden tulips. He hangs plastic fruit from real trees and bedpans by the front door. A sign reads: "Beware of wife, dog is okay." Gladys has no time for the occasional visitor who thinks she ought to be offended by the sign.

The Stewarts have had visitors from all over the world, and the question asked most often is how they manage to keep the grass mown. "Gladys moves the things aside and I cut a row. She puts 'em back and we do the next row."

"I tell you what really does our hearts good," says Bert, "is when the buses come from the hospitals and the old folks' homes. In good weather we get one a week each from the Jubilee Hospital in Vernon and from the Pioneer Lodge in Salmon Arm. To see those old folks' faces light up is wonderful."

The last time I spoke with Bert it was during the off-season. He had moved everything into storage and was dreaming up projects for the spring. "Wife and I got one going now. We do everything together these days. A big iron bed with roses growing in it and through it. Going to put it in the middle of the lawn. Our bed of roses."

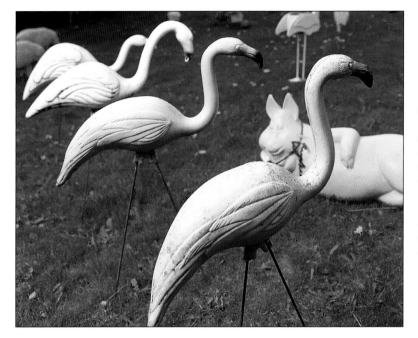

Bert and Gladys Stewart's property is a home for unwanted lawn ornaments, and Bert makes plenty of his own as well. When it's time to mow the lawn, Gladys moves the ornaments row by row, and Bert mows the grass.

(Below) The Stewarts rest after mowing their lawn, unaware of approaching cat. Note realistic-looking dog.

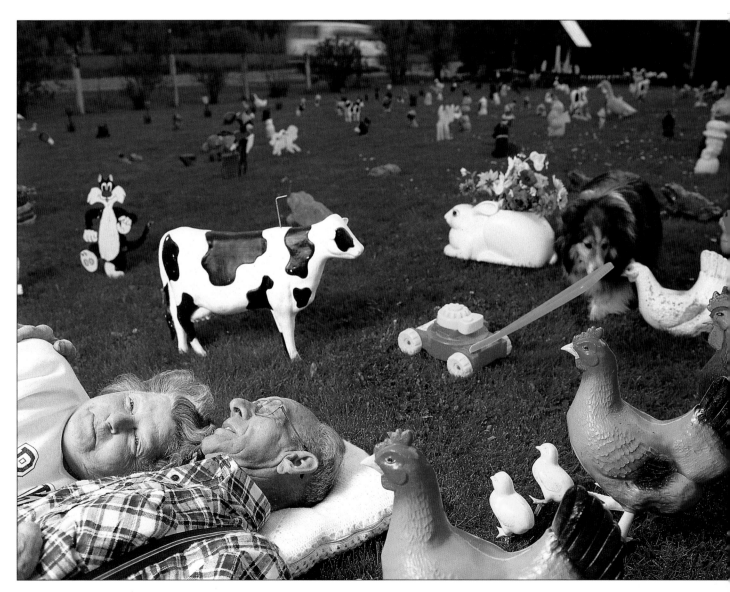

ACE'S WILD WEST

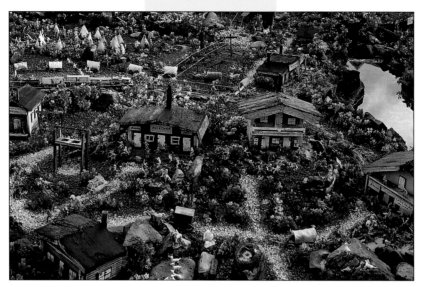

Lloyd "Ace" Parsons
Vancouver, Washington

WHEN I ASKED PEOPLE IN VANCOUVER, A CITY IN SOUTHWEST WASHINGTON, ABOUT "THE WEIRD HOUSE I'VE HEARD ABOUT," THERE WERE SECRET, KNOWING SMILES AND SARDONIC NODDING OF HEADS, BUT NO ONE LAUGHED AND NO ONE TOLD ME WHAT TO EXPECT. THAT WOULD HAVE BEEN LIKE GIVING AWAY THE PUNCHLINE. UPON SEEING LLOYD AND CLAIRE PARSONS' HOME, I UNDERSTOOD.

You approach the place tentatively, thinking of toys come to life in the store at night, of custard pies in the principal's face, of young Tom Edison gone astray. The fence is divided into hundreds of squares painted yellow, green, blue, red and white. The horizontal tongue-and-groove boards that make up the outside walls are done in the same colours. The porch is a geometry lesson. White trellises at the sides sport plastic flowers, and the rooftop is a galaxy of stars.

The foundation stones at the rear are painted gold and bronze, yellow and different shades of green, and each stone outlined in black. Against the back wall is the frog village. Half the yard is taken over by Dodge City and environs.

Lloyd "Ace" Parsons, the creator of all this and more, looks like a guy who might have come to Dodge gunning for Matt Dillon, or, several decades later, hung around with Elvis and Gene Vincent down at the service station. "When they took *Gunsmoke* off the air I got angry," he says. He wrote letters to the network and when they didn't put the show back on, "I decided to make my own Dodge City. It's the first bit of unusual stuff I did around here."

It is an immense display of tiny rubber cowboys, Indians and animals, an entire handmade miniature town with homes and businesses, city streets and country trails, hills, gullies, rivers and arroyos. Dozens of vignettes present gunfights, Indian battles, holdups, posses, drunks in the gutter, wagon trains arriving from the east, and gentlemen escorting ladies past Wells Fargo, the Golden Nugget and EATS, to the church on the hill. "Once I got started," says Ace, "I couldn't stop."

It was even more work than it looks. Ace wanted the display to be permanent and low-maintenance, so "I dug up the yard and laid down 2,000 pounds of rock salt, painted green. On top of that went gravel, also painted. Every figure in there, every cowboy, Indian and animal—" (there are thousands of them) "—has a nail through the base and is cemented into place."

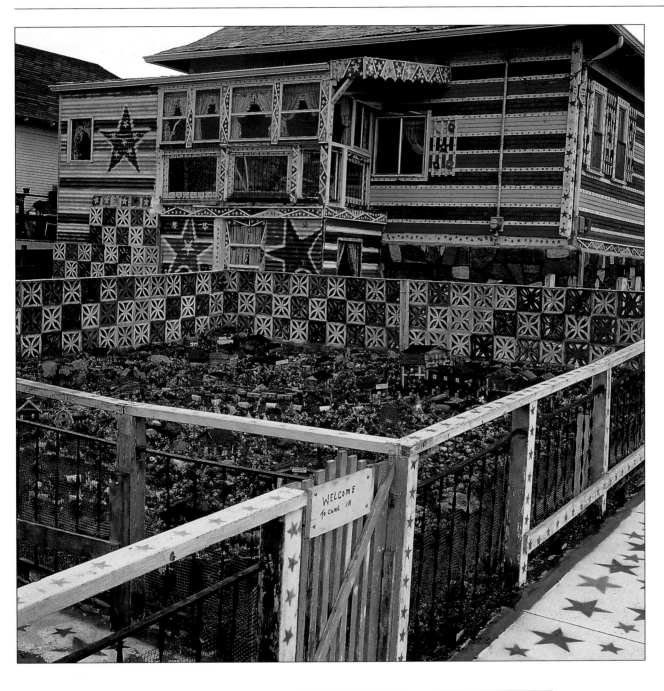

(Right) Ace Parsons, creator of a sprawling miniature Dodge City complete with gunfights and Golden Nugget, greets a couple of his eight thousand annual visitors.

Ace's back yard would be just the place for some young aspiring Louis L'Amour to come with his notebook to study and swipe story ideas.

"Know how I get the water into Dodge City for the rivers and lakes?"

"No idea."

"It comes off the roof, down a pipe that runs through Frog Town and into Dodge."

I take a closer look at the stagecoach, which is pulled up in front of a building with a ROOMS sign. There I can make out Claire Trevor and John Wayne, and I'm trying to figure out which is Donald Meek when a voice calls out a greeting. It is Claire Parsons, peeking out of the upstairs kitchen window, the painted curtains making a starry mantilla for her hair. She invites me inside.

I step into a sort of back-porch grotto, with more stars painted on walls and ceilings. In fact, there are stars everywhere throughout the house. Narrow stairs lead up to the kitchen where Claire stands before the ultimate magnet-and-stick-on-

decorated refrigerator. I mention the Spanish lady dolls on top, and she says, "Oh, no. They're not mine. Ace is the doll collector."

"I have three hundred and sixty of them," her husband says. And they are all on display in the house.

As well as dolls, he collects radios and music boxes encased in model cars, trains, fire engines and horse-drawn carriages. The best display of these is on the blue, green, white and gold painted see-through shelves that divide living and dining rooms. Dangling from the top of the passageway between the cabinets are mobiles of gold or indigo glass. Ace made these by drilling a hole through each piece of glass and stringing them together with fishing line.

From the cream-and-orange ceiling hangs a large mirror ball, and this big globe has six smaller satellites. At one corner of the living room, the walls are covered by mirrored tiles with black swirls. Several dolls are secured to one mirrored

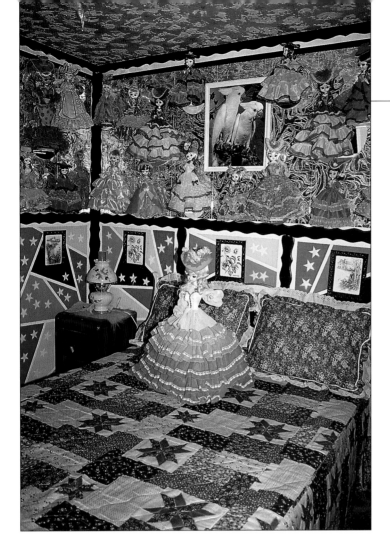

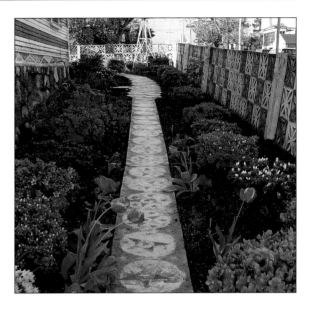

The first time I visited Ace and Claire Parsons' house, I was on the path (above) when a fellow who was none-too-steadily making his way along the sidewalk, shouted, "Hey!" I turned, he raised the paper bag to his lips, drank, and said, "Fine example of an outsider environment, is it not?"—and staggered off, along his way.

wall; they encircle an oil painting of four parakeets against an orange jungle background. More bird souvenirs perch throughout the house, most conspicuously amidst the doll collection in the bedroom. There, guarded by several satin and lace replicas of pre-Civil War New Orleans debutantes, is a large painting of two refulgent cockatoos.

On another bedroom wall, a host of heavenly angels hover about a picture of Jesus crucified from many perspectives.

The bathroom inspires you either to linger or to jump out the window. The toilet seat is a psychedelic throwback, and the walls are a cacophony of ceramic tiles, no two alike. They and the bathtub bear many rubbery stick-ons, mostly colourful snowflakes and some butterflies. Owls of glass, plastic and porcelain line the shelves, and more of them outline the mirror along with a few woollen bows. Dolls are posted at the corners and ceramic rooster plates hang just below the ceiling.

On the front porch you can stand under dozens of stalactites made from ribbons, chimes, plastic bougainvillea and satin bows, and look through yellow, white and orange curtains at the mundane houses of the neighbours.

More than a hundred satin bows adorn the yellow and green basement ceiling. Ace shovelled out the basement himself, "five hundred wheelbarrows worth of clay." Then he divided the space into rooms and decorated them. In the middle of the colourful profusion is an electric organ, gleaming in its polished wood cabinet.

Claire has taken no part in any of the decorating. "It's all his doing. I like it and I only wish he'd find something else to do. Now he's starting to drive me crazy because not only is he retired but we've run out of space. He doesn't know what to do next."

"That's right, I don't," says Ace. "I'm used to working at something all the time. I used to install sheetrock all day, then come home and work all night on the house." He nods toward the organ. "I did teach myself to play that."

His gaze lingers on the organ. It is so pristine, so downright weird in its natural state. Ace must be thinking the same thing, and wondering if it might not look better with some nice yellow and green stars, or maybe black triangles, a few cherubs at the corners . . .

BOSWELL BOTTLE HOUSE

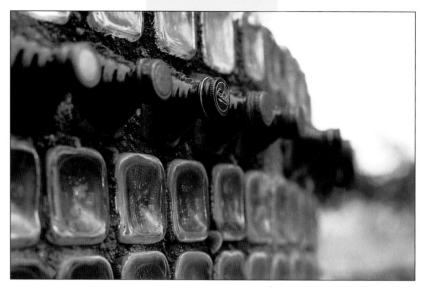

David Brown
Boswell, British Columbia

ONE OF THE PROBLEMS OF LIVING IN A GLASS BOTTLE HOUSE MUST BE THE PEBBLE-BRAINED CUTLINES CAST BY WITLESS NEWSPAPER AND MAGAZINE EDITORS. I HAVE DUG UP ARTICLES ABOUT GEORGE PLUMB (CREATOR OF THE BOTTLE HOUSE, DUNCAN, BC) AND DAVID BROWN IN DIFFERENT PAPERS, IN DIFFERENT CITIES, BOTH HEADED "HE'S ALL BOTTLED UP."

The fact that David Brown built his home in Boswell with 600,000 *embalming fluid* bottles only adds fuel to the wisecracks. But anyone who has seen the place could not fail to remark on its singular beauty.

Perched on granite high above Kootenay Lake, the house looks as if it might have been designed by an architect who caters to the sort of wealthy who have taste. From a distance it seems put together with blocks of polished marble in the style of a medieval castle, complete with crenellated roof. But when you get closer you realize that the outside walls reflect the sun, the shadows and the shimmering waters of the lake.

The house is 48 feet long and 24 feet wide, laid out in a cloverleaf pattern with circular rooms and 1,200 square feet of floor space. Polished and lacquered stone steps lead up to a kitchen overlooking a bottle-and-stone wall beyond which the hill slopes down to the lookout tower, also made of bottles. Small outbuildings and a bridge are made from even more embalming fluid bottles. To be in its presence is to be disconcerted, because the structure is an eccentric masterpiece, yet it appears perfectly respectable.

The house is the result of an all-consuming passion. It was a massive project for one man, and it exists only because that man contracted sleeping sickness.

David Brown worked as an undertaker in Red Deer, Alberta, and around about 1950 he began to drop off to sleep at odd times of the day. This proved inconvenient and sometimes embarrassing. Finally, in 1952, Brown's doctor told him to retire, to remove himself from anxiety and pressure. Brown quit his profession of thirty-five years, hitched a fourteen-foot trailer to his car, headed west and didn't stop until he saw Kootenay Lake.

He had long dreamed of building his own house, but doing it differently. He had experimented with various materials back in Red Deer, making tests with beer bottles and logs and concrete. When Brown moved to BC, he carried with him a few mementoes of his working days—the foot-tall, square-bottomed embalming fluid bottles. He liked the look and form of them, but it was a while before it occurred to him that they would make excellent building blocks. When he realized they were perfect for the house he envisioned, Brown had to get plenty of them.

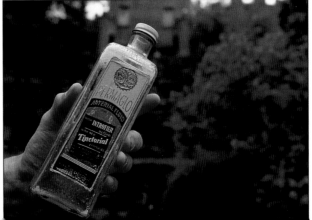

In the 1950s, embalming fluid came in bottles like this (right), and the late David Brown collected over half a million of them while travelling as an embalming fluid salesman. When he had enough bottles, he quit his job and started building his house (above), a 1200-square-foot home that reflects the sun, the shadows and the shimmering waters of Kootenay Lake.

With the help of old contacts, he took a part-time job selling embalming fluid, travelling a route from Victoria, BC to the Lakehead country of Ontario, in a 1-ton pickup truck, selling the product and keeping the empties. When he had enough bottles, Brown quit the job and started building.

Nowhere are the walls of the house wider than the length of a single bottle. Yet architects have estimated that because of the air trapped inside the bottles, the insulation provided is equivalent to 40 inches of glass fibre matting. The

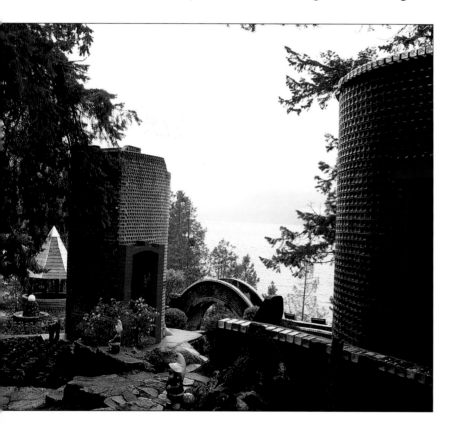

living room fireplace keeps the entire house comfortably warm during the long winters.

Brown built the walls so that the bottle bottoms face outwards, and electrical wiring is threaded around the necks. The inside walls are made of cedar boards, which are attached to strips of wood wired and mortared to the bottle necks. At the tops of walls and bridges, one side of each bottle is visible, the necks tapering into concrete. Occasionally you can read a label and find out that different chemicals are used for pre-embalming, and in arterial and "cavity" work.

Two years and over 100,000 bottles after he began construction, Brown was able to send for his wife in Red Deer and move out of his trailer. No sooner had they moved in to the house, in 1955, than the Browns were supplementing their retirement income. "It got so we couldn't eat our meals without someone peeking in the window to watch us," says Brown's stepson Eldon. "A minister told Dad that if he charged admission, they wouldn't come by. The minister was as wrong as he could be."

During a good summer week in the late 1950s, Brown could take in $1,000. Soon the family had to hire staff to admit people and to answer their questions. This allowed Brown to wander freely about the property. "People thought he was just the gardener," recalls Diane, Brown's daughter-in-law. "He was a normal-looking man, and most visitors figured the person who'd built an embalming fluid bottle house must be strange and wild-looking."

Since Brown's death in 1970, Eldon has landscaped the property, planted flowers and set out numerous plaster lawn ornaments. Diane operates the refreshment stand and gift shop, and there are cars in the parking lot from May to October.

And, Eldon says, the questions never stop. "People say to me, doesn't it feel strange living in a place made of embalming fluid bottles? And I ask them what their homes are made of. If they tell me wood, I tell them, well, caskets are made of wood. If they answer cement, I remind them that's what vaults are made of."

PLYWOOD MENAGERIE

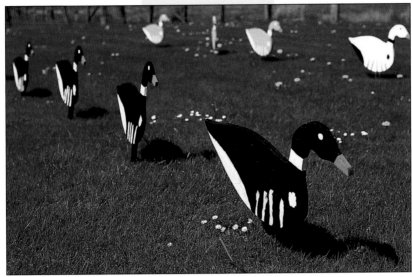

Donald Davis
Carnation, Washington

THE FRONT YARD AND MOST OF A FIELD AROUND A HOUSE AT THE SOUTHERN END OF CARNATION ARE FILLED WITH PLYWOOD CUTOUTS OF DUCKS, CHICKENS, DINOSAURS, RABBITS AND PIGS. THE UNLIKELY CREATOR OF THIS DISPLAY IS DONALD DAVIS, AN EX-LOGGER IN HIS LATE SIXTIES WHO STANDS A HUSKY SIX FEET FOUR AND HAS ROAD MAPS OF CHAINSAW SCARS ON THE BACKS OF HIS HANDS.

Davis is pleased when people are interested in what he does, but he also seems somewhat surprised. One of the local papers took his picture, but never ran it. "Every once in a while," he says, "some folks stop the car and get out for a look."

The plywood animals are lined up in long rows. The pigs have upturned smiles, the dinosaurs look goofy. A big-bellied pig is followed by a string of little red piglets. "It's a heck of a thing to have to mow that field," Davis says. I notice that broken bottle necks are strung along the fence wire, and dark blue bottles stand upturned on pegs over the gate. An iron derrick-type structure serves as a wind-mill, and handmade driftwood wind chimes hang from tree branches. "Well, I ran out of yard and I had to keep doing stuff."

He seems a trifle embarrassed about all of this, as if a visitor might regard it as not quite appropriate—a big old guy like him cutting out plywood pigs and hanging wind chimes from trees. But when I ask to see his workshop, Davis is glad to be taken seriously. He shows me his band-saw and his jigsaws, a neat stack of wood, and boxes of odds and ends awaiting his attention.

"I never set out to do things like this," he tells me later, as we stand on the grass among a dozen white bunny rabbits. "My wife was taking a mosaic class. She said she wished she had something interesting to paste glass and tiles and stuff on to. So I started cutting out figures for her." He points to a cement owl, studded with seashells and mounted on a tree. "That's the first one I cut out for her and she covered."

His wife died a few years ago, and "one day soon after, I found myself cutting out a figure. It kind of made me feel close to her. Like she was still here and I was doing it for her."

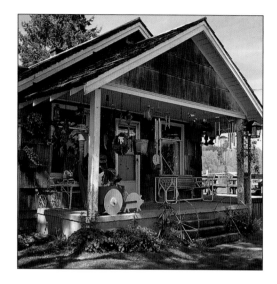

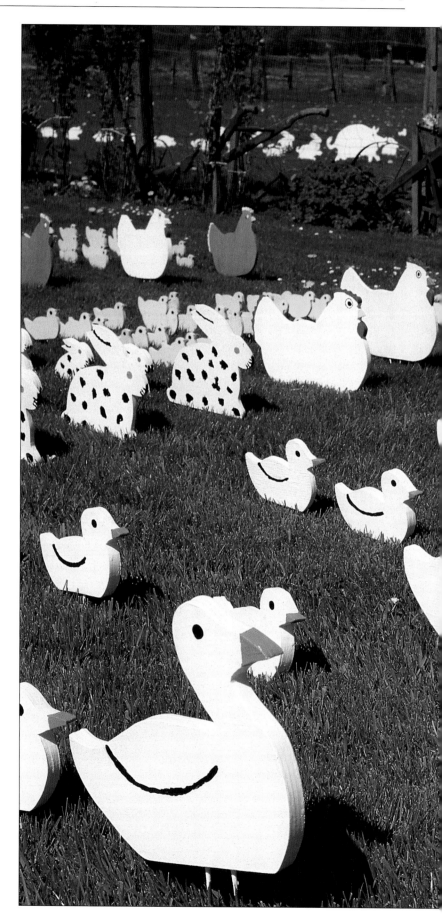

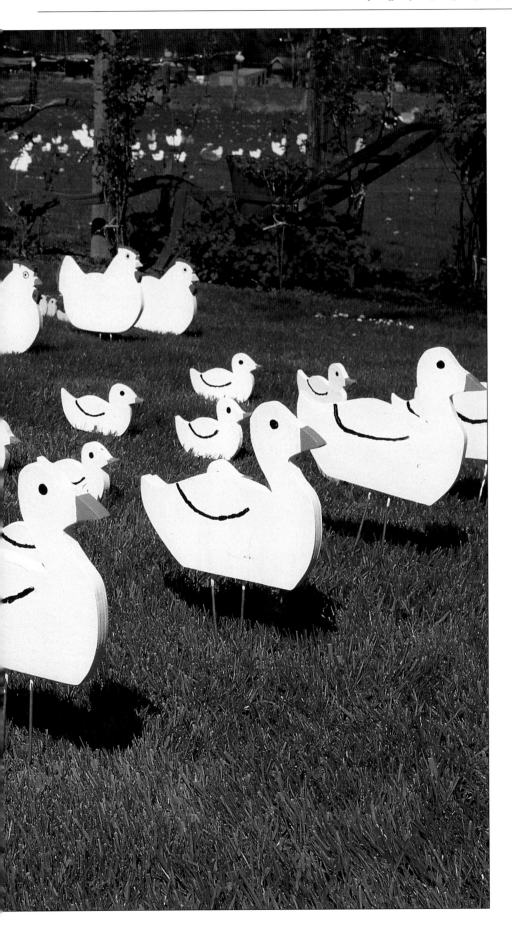

Donald Davis (below) started cutting out plywood figures for his wife, who liked to decorate them with glass and tiles. Before long the yard was filled with creatures. The wind chimes, bottle-decorated fence and other embellishments came later, when "I ran out of yard and I had to keep doing stuff."

THE HERMITAGE

Charlie Abbott
Chemainus, British Columbia

NOBODY KNOWS WHEN THE HERMIT CAME TO CHEMAINUS. ALL OF A SUDDEN, SOMETIME IN THE

LATE 1970S, THERE HE WAS, ALREADY AN OLD MAN, LIVING IN THE WOODS NEAR THIS EASTERN

VANCOUVER ISLAND TOWN.

Maybe a hiker had her sylvan musings interrupted by the sight of him at work—gaunt, bent, lugging a stone—and returned to town with a report of an old nut out there making stone steps and planting flowers in the middle of the forest.

By 1989 when he died at the age of eighty-seven, the Hermit—who, it was discovered, had a name, Charlie Abbott—had cut several kilometres of trail, lined much of it with stone, and built elaborate rockeries and walled gardens. Nobody knows why. He was little given to conversation, and offered no explanations.

When Abbott arrived, Chemainus was a fading sawmill town, but since the early 1980s the place has undergone a civic boom. A man called Karl Schutz had the idea to turn Chemainus into an outdoor art gallery. He hired artists to create murals on the sides of unused buildings, which were soon back in use and supplying the wants of armies of tourists.

In his wanderings around

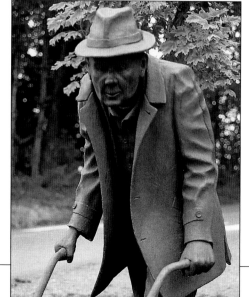

Chemainus, Schutz inevitably encountered Charlie Abbott. At first the Hermit would disappear through a curtain in the rain forest; then the two men occasionally exchanged a few words; finally Schutz became the closest thing Abbott had to a friend. "He was living under some tree limbs and lengths of two-by-fours covered with tarps," Schutz says. "Underneath was just a pile of blankets and coats where he slept. Later, some of us managed to get him an old trailer."

The property where Abbott camped was owned by MacMillan Bloedel, the huge forest corporation. Even though the company was not using the land, and Abbott certainly was not misusing it, they ordered him to move. "I went to Mac Blo," says Schutz, "and told them, after every kind of plea had failed, that if they kicked him off the land, all they'd get was bad publicity. You know, Forest Giant Evicts Harmless Hermit. But they didn't see it like that, and I wound up buying the land so he could stay there."

As I explore the site, walking the trails that Abbott cut and lined with stones, looking at his rockeries and garden patches, I try to picture him on the day his obsession took hold. This was a man rumoured to have spent plenty of nights sleeping under a bridge with a bottle, in one city or another. Nothing in his sketchy biography would foreshadow his work in Chemainus. Maybe one day, like the postman Cheval, he was attracted by the look or shape of a certain stone. Maybe he picked it up, turned it over in his hands, placed it just so, and later found the right one to put on top of it. Or, more likely, Abbott came across a stone that attracted him, but a corner or some other detail wasn't quite right, so he chipped off the part that offended him. Abbott did a lot of cutting and reshaping. In the middle of the rain forest, he made walls and fashioned hundreds of stone steps, all without mortar.

Now, several years after his death, the forest has blurred some of the fine details, but his work has stood up to time. Was Abbott a stonemason or bricklayer in his youth, before he took to drink? I'd conclude that he wasn't, but not because the work isn't good enough. It is, in its way, better. There is none of the professional's clean rigidity that often amounts to downright prissiness. There is a wonderful asymmetry to all this strange obsessional stonework.

Karl Schutz's latest project is an audacious plan to extend the town-as-art-gallery concept into an Artisans' Village comprised of workshops for craftspeople from all the Pacific Rim nations. The village will occupy a fifty-acre site, most of which is taken up by the forest through which Charlie Abbott wound his trails. At the village's entrance gate is a statue of Abbott pushing a wheelbarrow, and the trails have been named for him.

It may seem ironic that a man who shunned his fellows now plays posthumous host to them. But there is no irony at all. Charlie Abbott not only wanted human contact, he must have been desperate for it. He did, after all, transform the wilderness with human pathways, a maze of them, all leading to a centre—and the centre is where he lived, even if it was under tarps and two-by-fours, on coats and blankets.

JUNK CASTLE

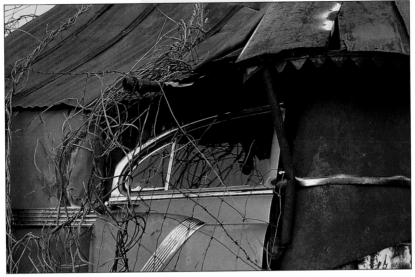

Victor and Bobbie Moore
Whitman County, Washington

A JUNK CASTLE ON A HILL IS ONLY THE FIRST THING THAT IMPRESSES A VISITOR TO VICTOR AND BOBBIE MOORE'S PLACE IN EASTERN WASHINGTON. THE SECOND IS THAT THESE FOUR AND A HALF ACRES APPARENTLY CONTAIN THE ONLY LIVING GREEN THINGS FOR MILES IN ANY DIRECTION.

The approach to the castle is artfully strewn with metal scraps like rusted wheelbarrows, snow shovels, bicycle fenders and plumbing pipe. A palisade of planks surrounds the entrance to the castle keep, and you enter through a doorway with a crown of ornamental ironwork. The hill has in no way been altered to accommodate this strange structure. The strange structure has been adapted to the contours of the hill.

Inside and out, the walls are constructed of sheet metal, tin, washing machine parts, dryer doors, the housings for huge metal fans, bedsteads, odd dome-shaped metal parts whose original functions are long forgotten, and the complete door and window assembly from a 1952 Olds 98. A narrow staircase with a wrought-iron railing is reminiscent of the staircase that leads to the top of the Vatican, but here the sunlight slants in through dryer-door windows and enhances other kinds of relics.

I looked out through the Olds window to sere hills, bare except for skeletal fenceposts. Only the twisted pipe turrets and bedpost standards protruded from the crest of the hill. From up there, the castle top looked like a cossack tent on the steppes, and small enough to be run over by the neighbour's combine.

Looking down from the turret to the moat, as it were, of junk was like perching on the shoulders of a giant and seeing his shoes planted in a scrapyard. The castle, the outbuildings, the vegetable garden, the poplar trees and the pond—this maculation on the agribusiness landscape is thoroughly and thoughtfully integrated. I was not surprised to find that Vic and Bobbie Moore are people with definite and sincerely held ideas about the environment.

Vic is recently retired from the local public school system, where he taught fine arts. The junk castle was his doctoral project in the late 1960s. He and a partner had worked on it, and both were considered anti-American hippies. "We were the long-haired troublemakers and the castle represented some dangerous alien notions. It took longer to build than it should have because every night when we were gone, the neighbour kids would vandalize it. I wouldn't be surprised if their parents had put them up to it. Things were tense around here in those days. People weren't used to anybody or anything different. It hasn't changed all that much, either."

Vic and Bobbie moved onto the grounds after they married, living in tents while they built the main house from railway ties. It is a beautiful place with substantial

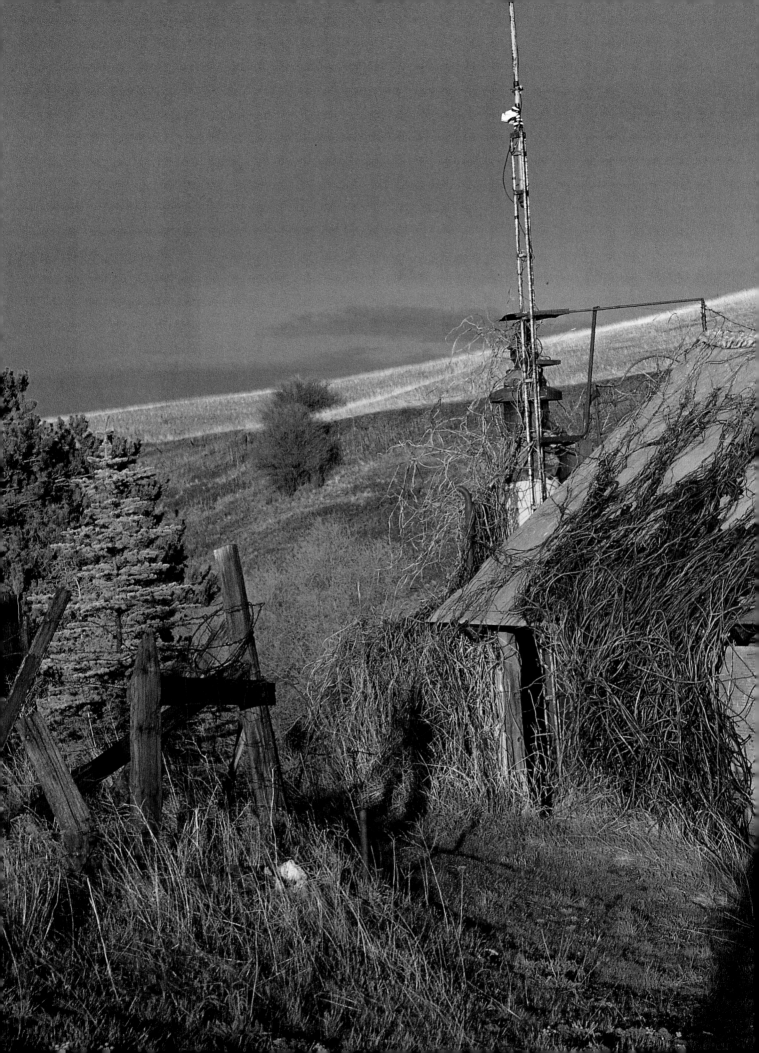

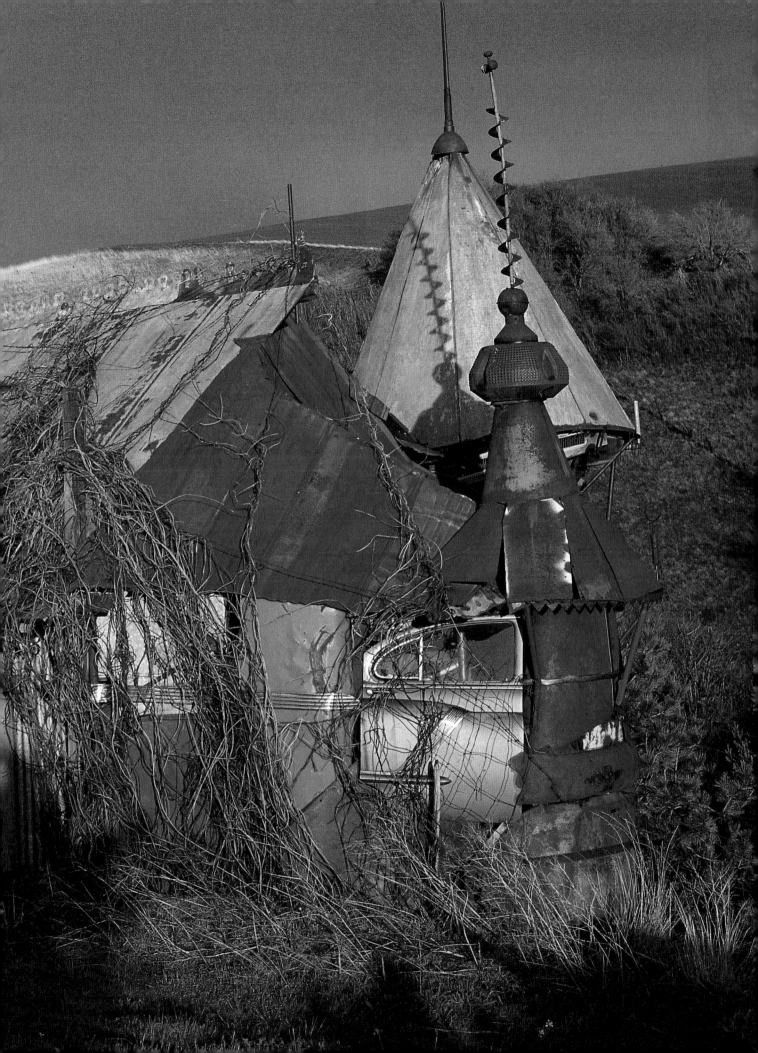

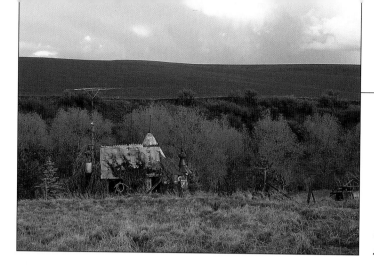

Vic Moore (opposite) is an artist who works with materials that range from tree branches to washing machine parts to railroad ties to waffle irons. He also works on various scales, from small sculptures (bottom) to the full-sized junk castle (below).

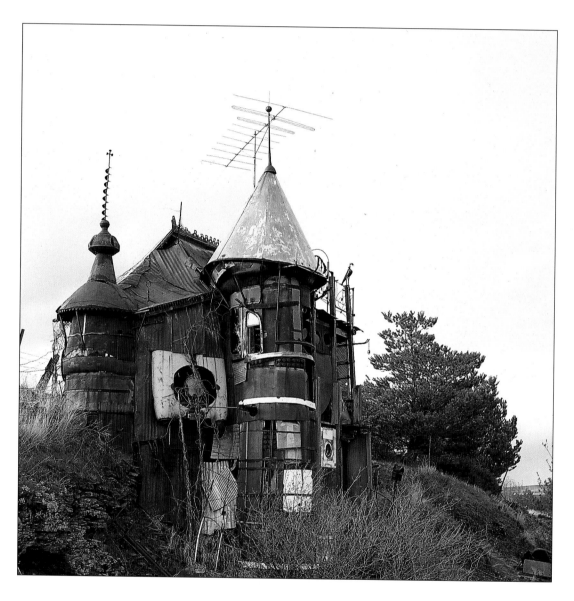

walls, the ties outlined with creamy white mortar. There are thick rugs, books, wildlife posters and Vic's sculptures and assemblages all around. His workshop is in the basement, cluttered with tools, more books, more art work. He is currently making and selling whirligigs, and scrapbooks chart the progress of his work from simple one-motion figures, like a man cranking a handle, to intricate Rube Goldberg contraptions.

As we walk down to the little pond filled with goldfish, birds chatter in the trees and a couple of deer feed in the late afternoon. "When we first moved here there was no wildlife at all," Vic says. "Whitman County is comprised of all these wealthy farmers, the small spreads running to about 2,000 acres, the trees all cut down to make it more economical to operate the machinery.

"This plot of ground was bare, too. The first thing we did was plant trees, which meant that soon there was shade, and grass could grow. It was also a little cooler, and birds began to visit. We started a garden and put in the pond and stocked it with goldfish. We got all sorts of new plants around the water, and even more birds. You see those silver and purple fish? They've just come back. We had them earlier and the birds particularly liked to get them. When the stock got low, the birds left them alone and went after the orange ones for a year or so, and the purple and silver ones replenished themselves."

In his old corduroys, flannel shirt and fishing hat, Vic Moore looks like the uncle you wish you'd had as a kid, the guy who'd take you on a hike and make the habits of the most common critter seem endlessly fascinating. But when he picks up a twisted tree branch, he isn't thinking of whittling by the campfire and dispensing woods lore. "I've been experimenting with tree branch art," he says. He sees arms and legs in motion, a knot that would make a face.

He leads me to a small barn, its walls covered inside and out with antlers, waffle irons, ceramic masks, tractor seats, sewing machine treadles and plumbing pipe. There are shelves sagging from the weight of more metal scraps, boxes and boxes of nuts and bolts, and cans and jars of paint. It is hard to tell whether the barn is a storehouse or a display.

Eventually the tour of the property leads back to the junk castle. We stand and look at it with different expressions and feelings. To Vic it is an old friend, maybe his own rapscallion uncle; to me it's a new if equally weird acquaintance. To both of us, the junk castle is also a welcoming sentinel at what is very much an oasis in the landscape.

WHIRLIGIG GARDEN

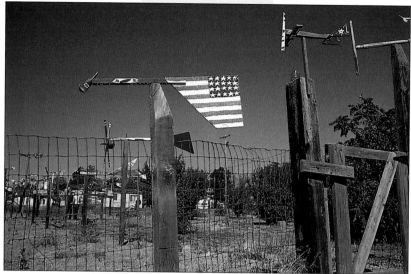

Leo Decker
Kent, Oregon

YOU HEAR LEO DECKER'S PLACE BEFORE YOU SEE IT.

KENT, OREGON IS OTHERWISE A QUIET HAMLET, A HUNDRED OR SO BUILDINGS BEDDED DOWN ON

THE PLAINS, UNDISTURBED BY THE WHOOSH OF PASSING CARS AND TRUCKS. MAYBE THE MOANING

AND WHISTLING FROM THE SOUTH END OF TOWN HAS PROVEN A WEIRD LULLABY.

But imagine yourself a lone traveller hiking down the road. You begin to believe you've heard a distant murmuring, then a keening sound, an angry whirring noise, the *thuwap-kathump* of a washing machine and the moaning of someone all but forgotten. It adds up to a cacophonic dirge more lonesome than any train passing in the night.

You approach, and from a rise in the land, look down upon a strange encampment, a house, jerry-built close to the ground, and for a couple of acres all around, poles topped by objects that churn the air with propellers of sticks and spoons, of fan blades and spatulas. There are a globe and a windsock on one pole, nylon ribbons on another. It calls to mind a battleground, the bodies removed but the standards still planted on the killing fields.

Leo shuffles out, squinting into the sun, tugging at the brim of his old hat. He wears jeans and a sleeveless sweater. His manner is gentle and he smiles easily, but there is hurt in his eyes. As he approaches, a dozen chickens emerge from a low shed in the middle of the field,

adding their clucking to the noise. "Leo" is tattooed on Leo's right arm, "Love" on his left.

Leo served in Korea, as a soldier and later an air force pilot. After he was discharged he did all right—he made a living and the memories didn't bother him. Then he hurt his back and shoulder. The pain was not relieved by surgery, and it brought back the horrors he had experienced in the war. Gradually, Leo began retreating from the day-to-day commotion of the world. "I found that I couldn't stand being around groups of people." As he talked, the chickens hovered about, the bolder ones pecking the ground around his boots.

Leo had loved flying planes, and one day he made a model from odd bits of wood and metal. It was just something to do, but when he saw the wind moving the propeller around, he decided to mount the plane on a post. He made another and another.

"Sometimes I didn't have the stuff to make anything that resembled an airplane, so I'd make other things." A spinning American flag made of tin, faces, horseshoe

assemblages, a tower. Lately he's put in a nine-hole miniature golf course with china figurines as obstacles.

Leo likes the sound of his place, especially at night. "I never thought I was doing something that other people would like. It pleased me. Every once in a while, I have a visitor who is curious. I like when people stop because it doesn't happen that often. Sometimes I'll sell one. A couple of weeks ago some Mexicans stopped by. They had finished work in Yakima and were going back home. They took four whirligigs with them."

I shook hands with Leo and got back into the car. Before turning onto the highway, I stopped for a moment at the edge of his property to listen one last time to that lovely moaning sound. Looking back, I saw Leo going into his house and the chickens returning to their coop.

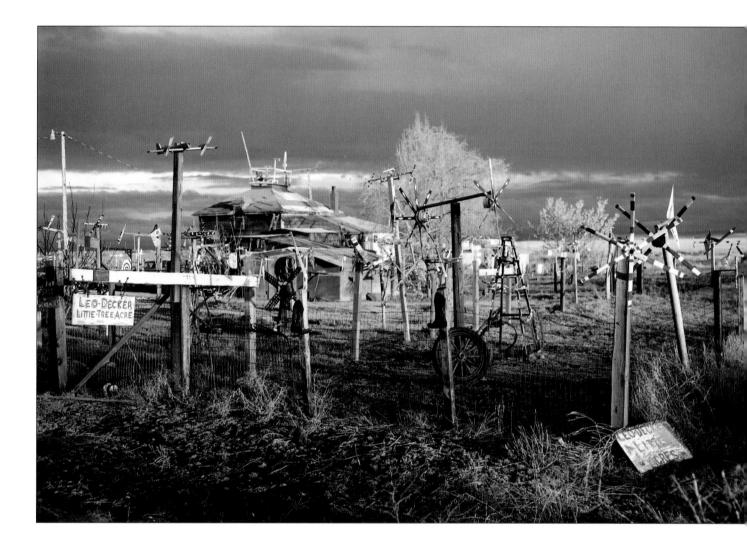

Leo Decker (left, with a friend) is a retired air force pilot whose first model plane led to a couple of acres of whirligigs. He makes them out of sticks, spoons, fan blades, spatulas, bits of wood and metal—whatever will make a pleasing sound when the wind blows through it.

33

DUNCAN BOTTLE HOUSE

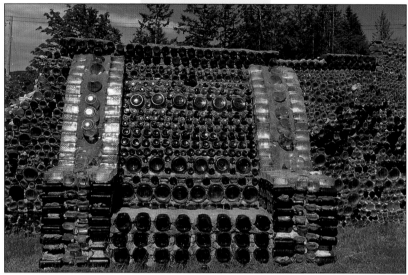

George Plumb
Duncan, British Columbia

LONG GONE ARE THE GLORY DAYS OF THE GLASS WORKS NEAR DUNCAN ON VANCOUVER ISLAND.

THE 200,000 BOTTLES WITH WHICH GEORGE PLUMB CONSTRUCTED HIS CASTLE, TAJ MAHAL REPLICA

AND BOTTLE TOWERS ARE CAKED WITH YEARS OF DUST AND DESUETUDE. WEEDS HAVE

OVERTAKEN THE FLOWERS THAT ONCE FLOURISHED AMONG THE STRUCTURES.

Now the property is up for sale, and the real estate agent put a couple of guys to work with a mower and scythe before the sign went up. "The place just looked too depressing," he says. "I grew up around here. It wasn't depressing in the beginning."

The beginning was 1962 when Plumb, a carpenter and construction worker, arrived from Saskatchewan and bought the one-and-a-third-acre piece of land on the Island Highway. A Canadian Pacific Railway bunkhouse and a tool shed stood on the property. Plumb set to work enlarging and remodelling these, but he was envisioning something different, something unique.

Palm Dairies, a local company, gave him three thousand empties. But Plumb wanted more sizes and shapes, so he put off beginning his project until he had collected whiskey and wine bottles, Pepto Bismol bottles, five-gallon cedar jugs, pop bottles and any other kind of bottle. Before long, he'd covered his three-bedroom house with bottles. He also put down a beautiful polished hardwood floor and built a fireplace of pink rhodonite to let you know he might be a trifle batty but he was also an artisan.

Long before Plumb got to work on the supplementary structures, visitors began to arrive. They took pictures and told people back home—in New York, Tokyo and Stockholm, among other places—and soon the mail brought press clippings and invitations. Plumb's buildings appeared in *Ripley's Believe It Or Not* and he himself turned up on the *Tonight Show*, playing harmonica for Johnny Carson.

George Plumb died in 1976, and the succeeding years have not been kind. The hands the property has passed through have not been those of artisans. A plywood fence, erected after Plumb died to insure no one got a free peek, could not have looked elegant to begin with; now it is shabby as well as cheap. Somebody installed a miniature golf course and continued the bottle theme, but didn't wash off the labels, so the bottles have escaped their mortar. The indoor-outdoor carpet at each hole is rotting, while a large plastic clown with an ice cream cone in each hand and an order window in his stomach stands by.

"Potential buyers, first thing they want to do is bulldoze the place," the real estate agent says. "Could have sold this place if the bottle buildings weren't on it."

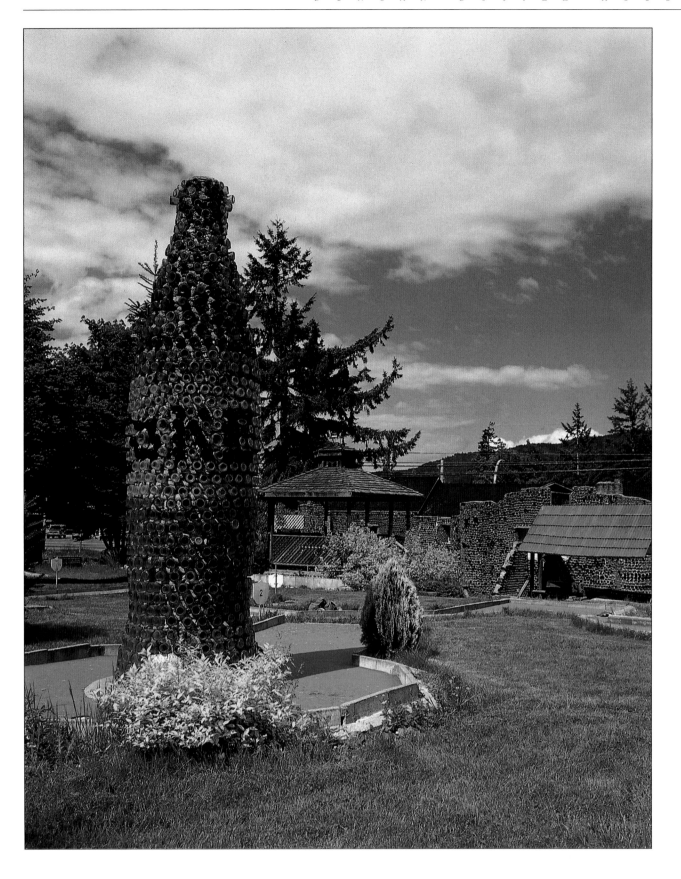

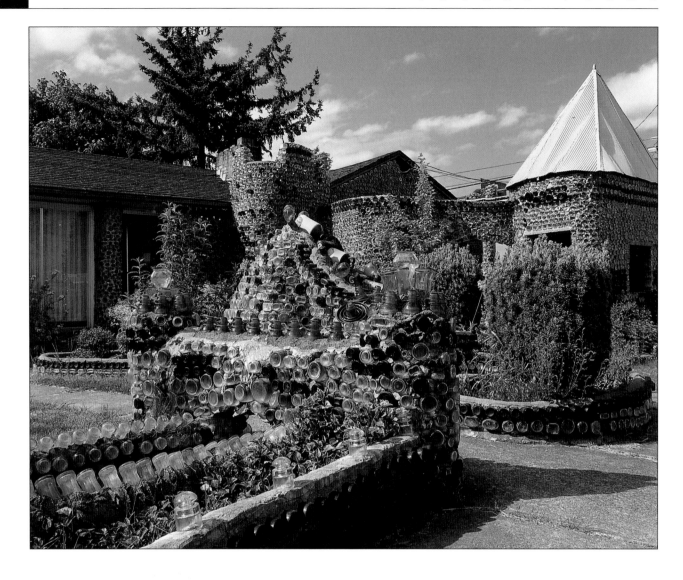

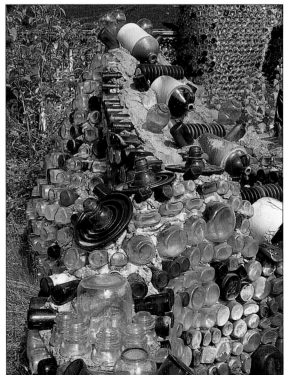

The late George Plumb collected milk bottles, pop bottles, five-gallon jugs, whiskey and wine bottles and every other kind of bottle to build his three-bedroom masterpiece on Vancouver Island. Visitors came from all over the world, and the structures were featured in Ripley's Believe It Or Not.

LITTLE MANSION

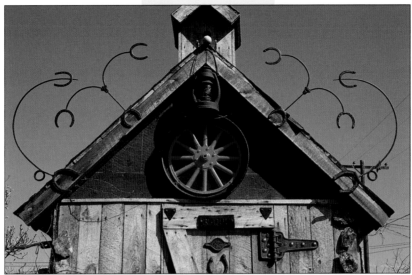

Tim Anderson
Roundup, Montana

THE LITTLE TOWN OF ROUNDUP LIES JUST NORTH OF THE BULL MOUNTAINS, NEAR THE MUSSELSHELL RIVER IN CENTRAL MONTANA. FOR MANY DECADES IT WAS A THRIVING CENTRE. THERE WERE PROSPEROUS RANCHES AND SEVERAL COAL MINES, AND THE RAILROAD STOPPED THERE.

But in the 1950s and 1960s the demand for coal dropped off sharply and the railroad abandoned the town. If that wasn't bad enough, the 1980s brought drought and falling prices for agricultural products.

But Roundup got a boost in 1989, the year of the state centennial. Thousands of visitors arrived to celebrate and watch the re-enactment of the great cattle drives of the previous century. Locals have been working to sustain that energy and optimism ever since—and now coal is back.

People around here have been politically conservative for a long time. Living through a hard patch just made them more so, and the sharp memory of those too-recent times has guaranteed that anything resembling liberalism won't find much grazing ground in Roundup. Visitors need only check out the bumper stickers on the pickup trucks out front of the Assembly of God church. The town's publicity may boast of the wild times and odd characters of the old days, and mention that Roundup has received all manner of immigrants, but that's just tourism stuff. Any differences were melted down long ago.

All of which explains why, when I inquired about Tim Anderson and his house shenanigans up on Seventh Street,

the leathery old cowboy bartender said, "Oh, that dinkhead! Somebody ought to put a stop to what he's doing."

What he's doing is transforming his little house and small lot, wedged between a stolid log home and a doughty double-wide, into a fantasyland of metal, rock and wood. He's erected pillars of car parts, posts of crankshafts and tractor tools, and portals from four-poster beds. Anderson's whirligigs stand on pilings that might have been salvaged from Atlantis. His metal birdhouse towers could be stately satires of the industrial age. He has built a three-storey shed with a scrap iron eyrie and is working on a two-storey version. Most of his buildings have wagon wheel windows. The wheels are set in square frames, triangles of glass are placed between spokes, and the corners and spaces between wheels are carefully filled with mortared wedges of sandstone.

Out in the yard, with hollyhocks climbing all around them in summer, are cars made of wood fragments and others made of iron castoffs. Anderson had a vision that an angel would appear and touch the cars, which would run forever more.

Tim's visions determine the shape and direction of his

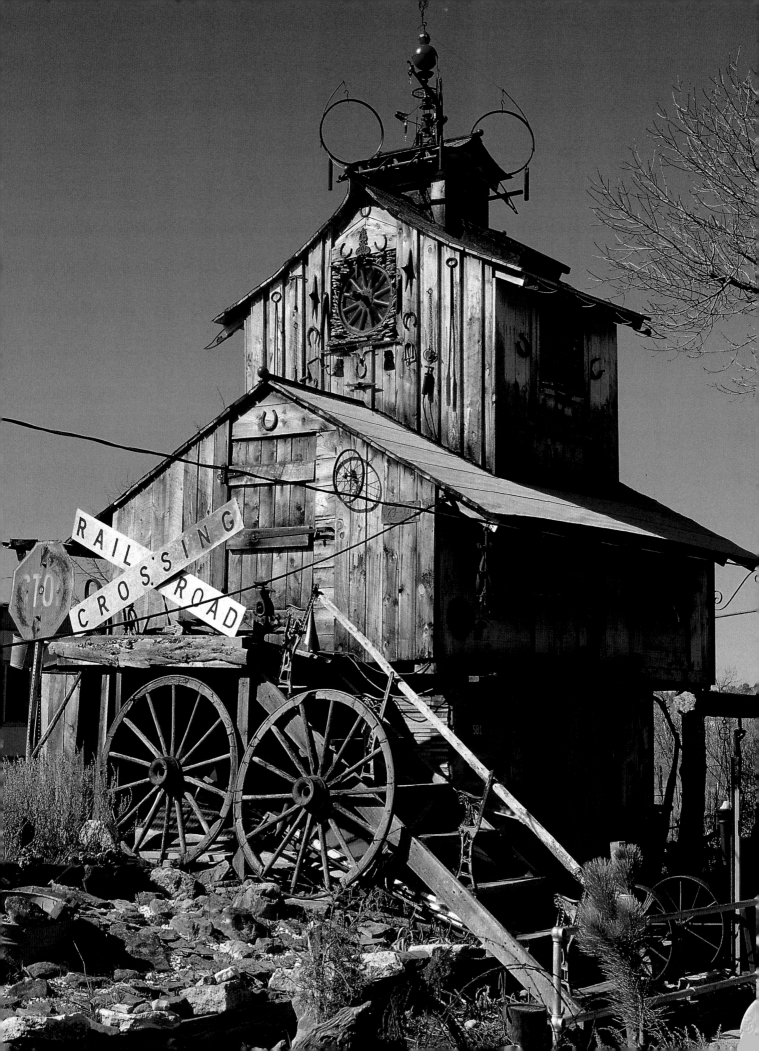

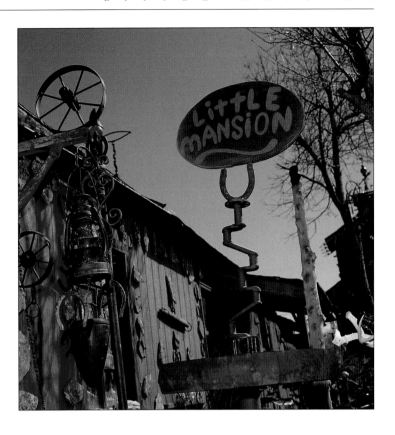

Like most of Tim Anderson's creations, the three-storey shed (opposite) in his small lot has a wagon wheel window and embellishments of car parts, tractor tools and whirligigs. "I see a rough picture in my head of what I'm trying to build," he says. "Sometimes it works, sometimes it doesn't."

yard work and of his life, which over the years have become as one. He had his first vision just after he had moved in, while he was puttering around outside and thinking vaguely about a rock garden. "I was bent down in the dirt and suddenly it came to me. There was a light all around. I can't explain, except to say I was directed to make something different. And to make it with junk."

Tim named his place Little Mansion, in reference to Little Falls, Minnesota, the town where he was born. As a kid he spent much of his time in junkyards and dumps there. "I didn't have toys. I played with junk."

Tim is only forty-one, but he seems older. Not that he looks older, rather he appears ageless. He has hypnotic blue eyes. When he isn't working, he rides around town on one of his antique bicycles, haunting secondhand stores and searching for scrap.

His guest books are chock-full of enthusiastic comments from people all over the world who admire his house and yard. It's just the locals who don't take kindly to what he's doing. But Tim makes no attempt to fight back. He doesn't even get angry any more. That all ceased one day near the end of his seven-year stint at the sawmill. He was having a hard time with one of his fellow workers, a guy who was riding him and making the work more difficult for both of them. "All at once I felt so at peace, and like my whole body was submerged in warm water." He smiled at the fellow on the other end of the saw, and soon the man relaxed. Tim sees this as the work of God.

And he figures it must be God who gives him the skill to do the work in his yard. Tim is untutored in art, and he has served no apprenticeship in metal or woodwork. But his work speaks eloquently for him. It is the product of a skilled carpenter and metal craftsman, a man with an innate sense of harmony and design.

Tim hopes that a rich person will be sent to him so that he can expand beyond his property line. He looks longingly at the big empty field across the road and the hill beyond, and explains how he would transform all of that. "Imagine it! Imagine if I had the whole town! The whole United States!"

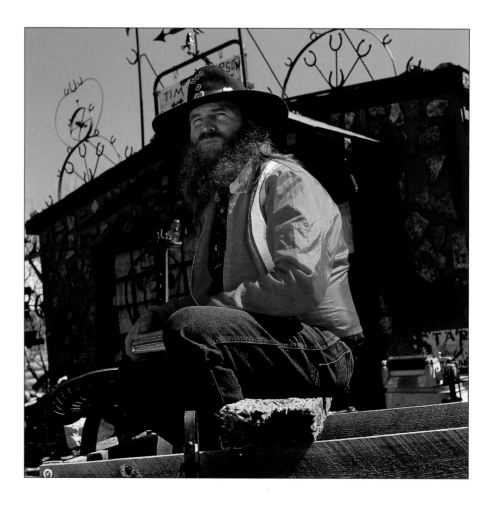

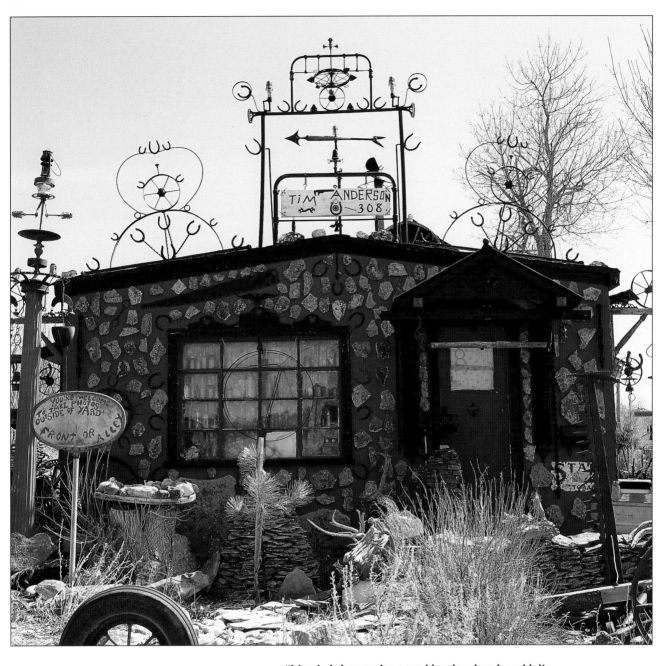

"I hauled river rock on my bicycle when I couldn't afford gas," says Tim Anderson (left). "I also hauled in scrap iron and pieces of machinery and antiques and built two buildings using wagon wheels and wooden-spoked car wheels for windows. Now and then I wonder how I ever did it—I have thirteen sheepherder monuments in the yard."

CRYSTAL VILLAGE

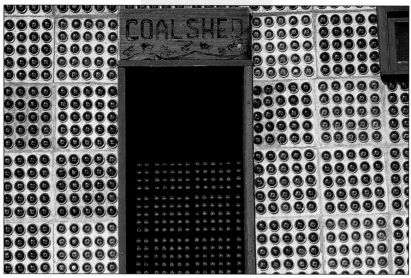

Bastien "Boss" Zoetmann
Pincher Creek, Alberta

A BATTERED SIGN ASSURED ME I WAS AT THE CRYSTAL VILLAGE. A THICK CHAIN DRAGGED ON THE GROUND BETWEEN TWO POSTS AND THE SUN GLIMMERED ON THE SIDES OF STRUCTURES THAT SEEMED TO SPROUT AMONG THE WEEDS. THERE WAS NO ONE ABOUT. TRAFFIC ROARED BY ON HIGHWAY 3. THE DOOR OF THE CHURCH SMACKED METHODICALLY AGAINST ITS JAMB LIKE A LAZY HORSE SWATTING FLIES, AND THE WIND MADE LONELY MUSIC AROUND THE CORNERS OF A COAL SHED. THIS WAS YEARS AGO, BUT I WAS ALREADY TOO LATE.

Yet the trails between the buildings were not overgrown, and hunks of coal still hid the floorboards in the shed. Pieces of coloured chalk waited in the pencil grooves of wooden desks in the schoolhouse. At the entrance to the church I found a donation box with coins in it, and a guest book in which the last entry was recorded by a family from Camrose, Alberta, nearly a year earlier.

Except for roofs and windows, the buildings were made completely from clear or green glass insulators, but the insulators had been used differently in each structure. The schoolhouse and office building were constructed of square wood frames, each frame holding twenty-five insulators. The framing was cemented over, the office building painted white and the schoolhouse deep red.

In the walls of the church, the builder had used as little mortar as possible between insulators, so the inside was washed in green light. When I sat in one of the handmade pews, the effect was like looking out from inside a vast illuminated honeycomb.

The belfry of the glass-insulator church mimicked the ubiquitous grain elevators of the prairie, some of which stood silently beyond the northern end of the Crystal Village. No one was around them either. A cross over the door identified the church as a place of worship, just as the golden shafts of wheat served as a logo of farm commerce.

What had happened here after the last visitors signed the book a year earlier? Why was the place deserted, artifacts still lying about?

Bastien Zoetmann, nicknamed "Boss," had died on December 14, 1989, his wife Burga told me. He had been a machinist by trade, but Burga referred to him as "more the adventurer type, always doing something different,

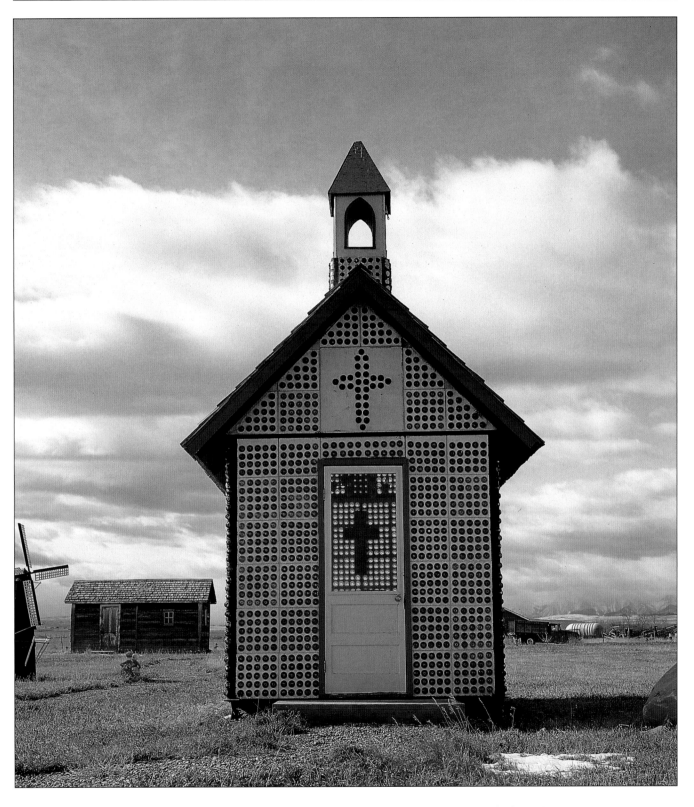

"Boss" Zoetmann built all the structures in his Crystal Village out of glass insulators from discarded telephone poles. The belfry of the church (above) is reminiscent of a prairie grain elevator. Zoetmann used as little mortar as possible between the insulators, so the church's interior is washed in green light.

jumping from one thing to the next."

Once he got the notion sometime in the mid-1970s to build with insulators, there were evidently no second thoughts. The thing had to be done. Zoetmann went around Alberta collecting glass insulators from discarded telephone poles and used 5,642 of them on his first project, a church for his Pincher Creek backyard. With the 150,000 insulators remaining, he made a school, playhouse and office, the coal shed and warehouse, and then realized he had the makings for an entire village.

But there was still more to be done. He had exhausted his Alberta insulator sources, so he acquired more of them from Holland, Denmark, Germany, Australia, Pakistan and Japan. These were recycled into more buildings. By 1986 he had run out of yard. Everything was transported to the new site, the property on the outskirts of town near the junction of Highways 3 and 6.

Burga says her husband was an incredible worker with seemingly endless reserves of energy. "He was at it till nearly the end, building, landscaping, taking kids around." Zoetmann had opened the village to visitors in 1987, and had arranged for school to be conducted and church services to be held. Next came the buffalo and the llama. No admission fee was charged, but he wouldn't turn down a donation.

The last thing Zoetmann made was a taxi stand, so the invisible residents could wait for invisible taxis. A few months before his death, he was still planning new projects—a castle and a large house for himself and Burga.

"It seemed to me that he died suddenly," Burga told me. "But after he was gone, I discovered he'd had the cancer for a long time but had told no one, not even me." After Zoetmann's death, the Crystal Village sat unattended and the weeds did their work. "I don't have the heart to even go out there."

Zoetmann was always disappointed by the reaction of locals to his work. "They didn't criticize him," Burga said, "they just sort of ignored him." Not long after I talked to her, the Alberta Historical Society arranged to have the buildings transferred to a park area near the site of the Old Man River Dam. Burga was assured they would be surrounded by antique farm machinery on a well-maintained plot of land. She considered this to be a gesture of official recognition. "Isn't that the way it usually is? They recognize you after you're dead."

Not long ago, I went out there to the Old Man River Dam and had a look at the buildings. The well-maintained plot of land is a featureless patch of the plains. No people, no friendly animals wander between the buildings. Neither are there grain elevators for reference points or traffic rushing by on Highway 3. The buildings just sit there forlorn while the wind blows relentlessly.

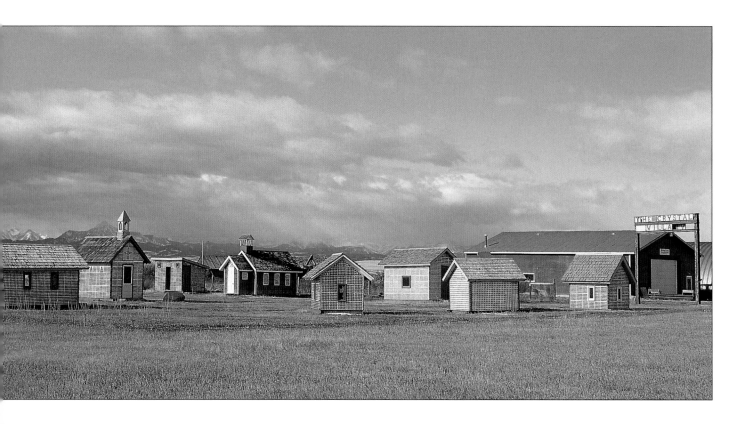

DICK AND JANE'S SPOT

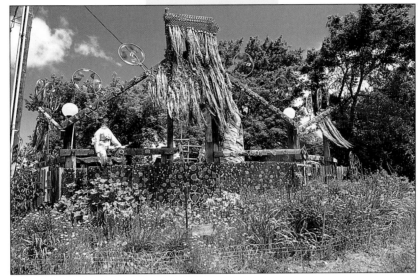

Dick Elliott and Jane Orleman
Ellensburg, Washington

AMBLING ALONG THE STREETS OF ELLENSBURG, AN UPSCALE COWBOY TOWN IN CENTRAL WASHINGTON, I CHANCED UPON A GENTLEMAN OPENING HIS SHOP, CALLED THE CRAZY FOOL BOOKSTORE. WE GOT TO TALKING AND IT MUST HAVE BEEN AN HOUR LATER WHEN I ASKED HIM ABOUT BIZARRE HOMES AND GARDENS IN THE AREA. "GO OUT THE DOOR AND TURN LEFT," HE SAID MATTER-OF-FACTLY. "LEFT AGAIN AT THE CORNER AND A BLOCK AND A HALF TO DICK AND JANE'S SPOT. YOU CAN'T MISS IT."

Not likely.

At first glance I took in a two-storey house painted deep red, with a blue tin roof, a giant hand above the front door and, on a side wall, fifteen-foot-tall panels made of car and bicycle reflectors. In the front yard were sculptures and assemblages put together from tree stumps, sawed-off telephone poles, more reflectors, bottle caps, chunks of wood and hunks of tin. I peeked through the slats of a tall wooden fence and saw what looked like a cross between a monastery garden, a junkyard and a mountain village in Irian Jaya.

Dick Elliott and Jane Orleman were quite friendly, especially considering that I had just awakened them. They invited me to look around while they made ready to face the day.

The yard cannot contain the enormous display, which climbs over the fence tops and trespasses in the laneways. Bicycle wheels on tree stumps, totems of tin and obelisks of junk stand up with the sunflowers at the perimeters. When Dick and Jane emerged again, they unlocked the door to a backyard phantasmagoria. It is a small area crammed with pieces, but feels huge because of the variety it contains. There are more bottlecap towers, stonework, funny fertility totems and a plywood elephant in a black suit. A big-mouthed wooden cat sits on a hydro spool surrounded by doll heads growing on sticks among violets and daisies.

Dick and Jane have been working on their property since the late 1970s, shortly after launching a commercial cleaning business. It is the success of this venture that has financed the vast amount of material making up Dick and Jane's mini-universe. Together they made the first pieces

for the yard, the reflector totems and bottlecap obelisks, but they were soon collecting other people's works, mostly folk or outsider artists. Among other pieces, the yard contains two wire sculptures, Man and Horse, by Reid Peterson; a lawn chair by John Harter; and Bob Lucas's concrete fish. In a corner of the yard is a tower, the work of Davy Simkin, on which bricks are laid in diagonal courses, which gives the illusion that the tower is leaning. Its concrete base is a mosaic of plumbing and electrical fixtures.

Now, with time to spare from the cleaning business, Dick and Jane can pay more attention to the yard and to their own art work. Jane, who paints in oils, is more prolific than ever and Dick

has started combining neon with reflectors to make room-size pieces. They want to give over most of the remaining yard space to their collaborative pieces, as well as enlarging their collection. In this way, not only does their spot continue to expand and evolve, it also provides encouragement to others working in raw forms.

"Our home allows us to have a dialogue with people without the filter of a gallery," Dick explains. "We can have art conversations with a farmer from Yakima who has a carload of grandchildren at the curb. He'd never set foot in a gallery. People of all kinds think it's alive and free and full of expression."

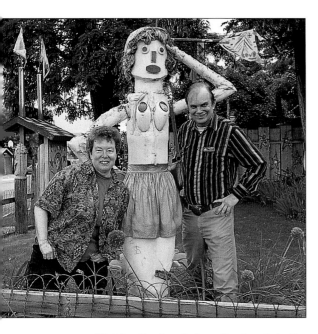

"Art for the heart, from the heart, in the heart of Washington," is the motto of Dick and Jane's Spot, a cowboy-town property that looks like a cross between a monastery garden, a junkyard and an Indonesian mountain village. Dick Elliott and Jane Orleman (above) offer the reminder that: "One hearty laugh is worth ten trips to the doctor."

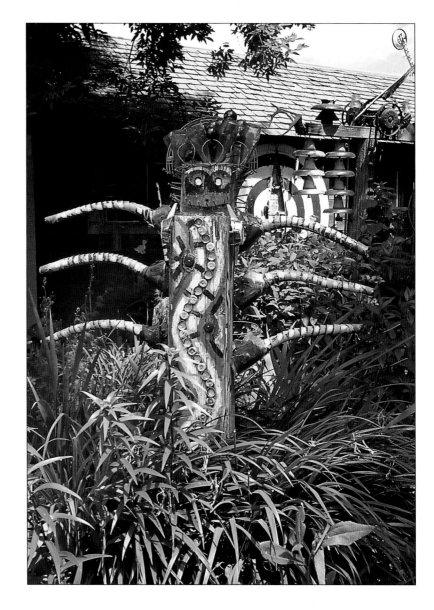

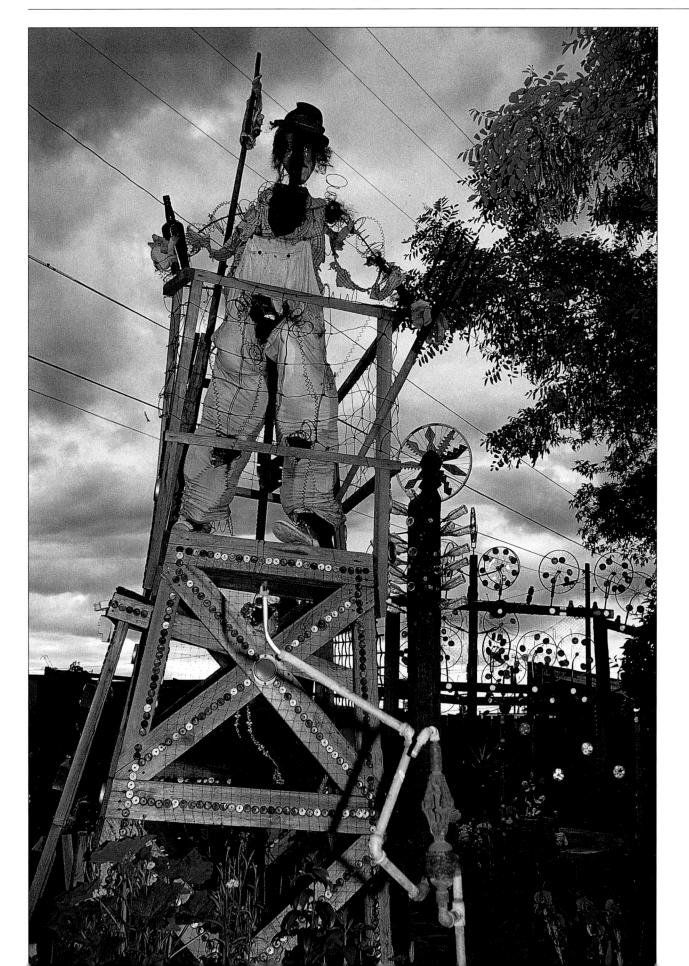

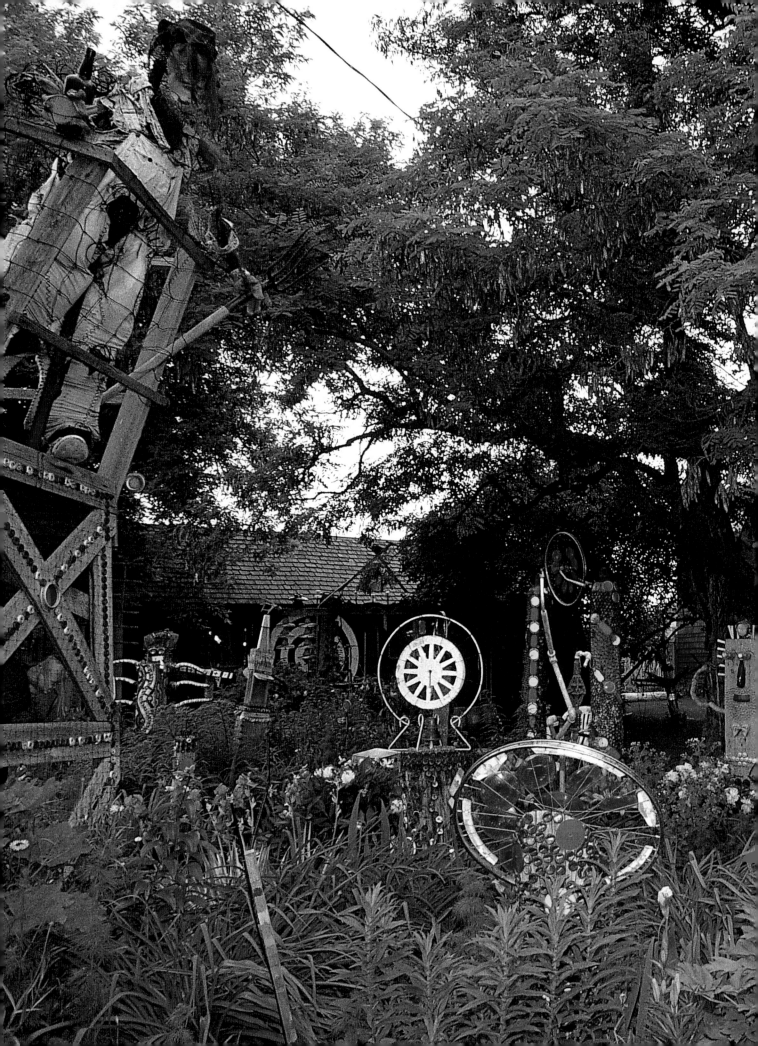

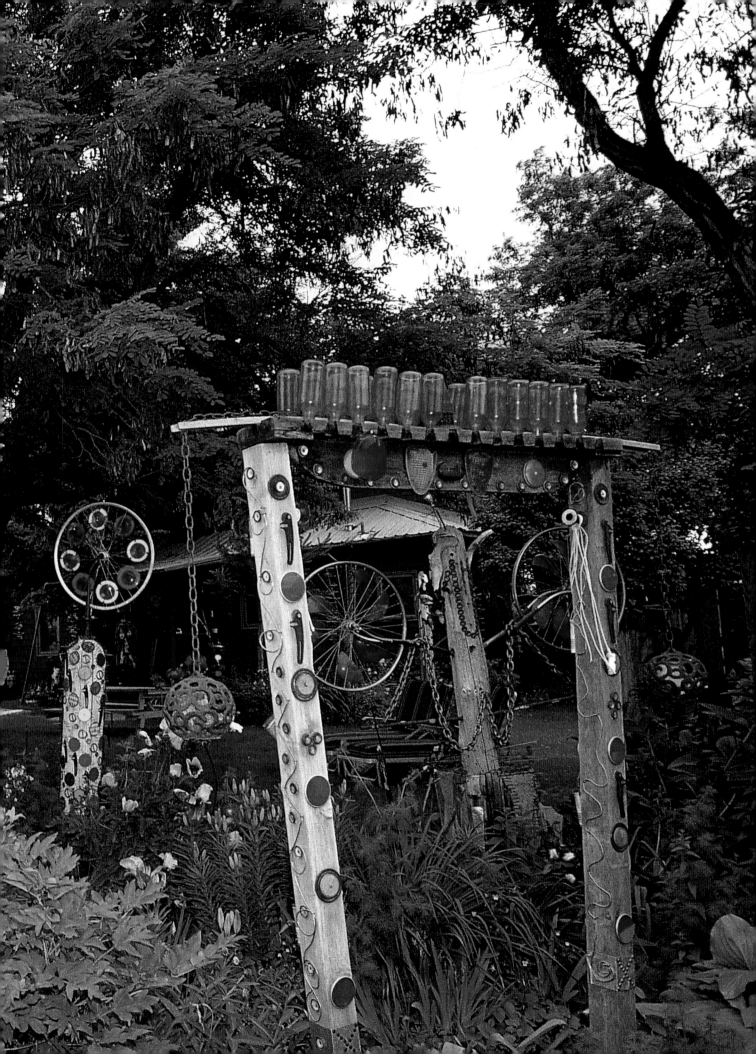

PETERSEN ROCK GARDEN

Rasmus Petersen
Redmond, Oregon

BY ALL ACCOUNTS, RASMUS PETERSEN WAS A WARM, FRIENDLY MAN, BUT HE MUST HAVE BEEN A

TOUGH, DETERMINED CHARACTER AS WELL. HE LEFT HIS NATIVE DENMARK AND ARRIVED IN

CENTRAL OREGON IN 1906 WHEN HE WAS TWENTY-THREE YEARS OLD, AND GOT TO WORK

CLEARING THREE HUNDRED ACRES OF ROCK AND FOREST.

He built his house and outbuildings and developed a prosperous farm there, just south of Redmond. When he was fifty-two, he finally had time to relax, but he didn't. There was a spot to the west of his house that had always bothered him because nothing would grow there. He tried everything, but there were all those rocks. . .

So, in 1935, Petersen started making a rockery, and he didn't stop. By the time he was felled by a sudden heart attack in 1953, he had covered four acres with rock displays that are both massive and intricate, of houses, castles, bridges and towers.

Petersen undertook the rock work for his own and his family's enjoyment, but it attracted attention almost from the moment he decided where to place that first stone. Sixty years later the visitors are still arriving, and the Petersen Rock Garden has become a family corporation operated by his stepdaughter, Mrs. Hegardt, and her daughter and son-in-law, Susan and George Caward.

The displays use agate, petrified wood, jasper, malachite, obsidian and thundereggs, among other kinds of rock. "No sooner had he started," Mrs. Hegardt recalls, "than people were telling him about different kinds of rock they'd seen, and he'd go and haul it back and use it to make something."

Petersen's patriotic monuments include a Statue of Liberty on a rock mosaic foundation and a large replica of a statehouse set above an American flag, the stars and stripes composed of different stones. "He loved his adopted country," Mrs. Hegardt says. "It accepted him and let him prosper so he honoured it with those displays. But since he was from Denmark, he'd seen a lot of castles, so he made them too." Petersen built the finest castle, along with other rock houses and lighthouses, in the middle of a pond he dug by hand. You approach these finely detailed structures by walkways and bridges. Below, there are frogs and ducks in the water, and hens, roosters and peacocks waiting on shore.

The entire rock garden, the work of this one man, is so unexpected and so prodigious an achievement that you have to walk around the four-acre site a few times before you can accept what you're seeing. But standing on a bridge looking up at the castle, you cease to be dazed as enchantment takes over.

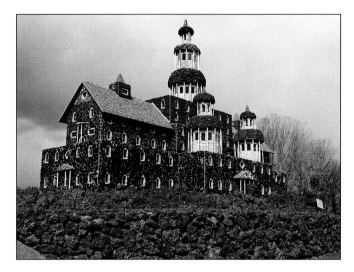

In 1935, at the age of fifty-two, Rasmus Petersen retired from farming and started building a rockery on a piece of his land that had been too rocky to produce crops. By the time he died in 1953, he had covered four acres with rock structures and displays made of jasper, malachite, obsidian, petrified wood, thundereggs and every other kind of rock. His "miniature" replica of a state house (above) is over twenty-five feet tall.

Petersen always maintained that hauling all the rocks for his hobby was hardly any work at all after the demands of farming.

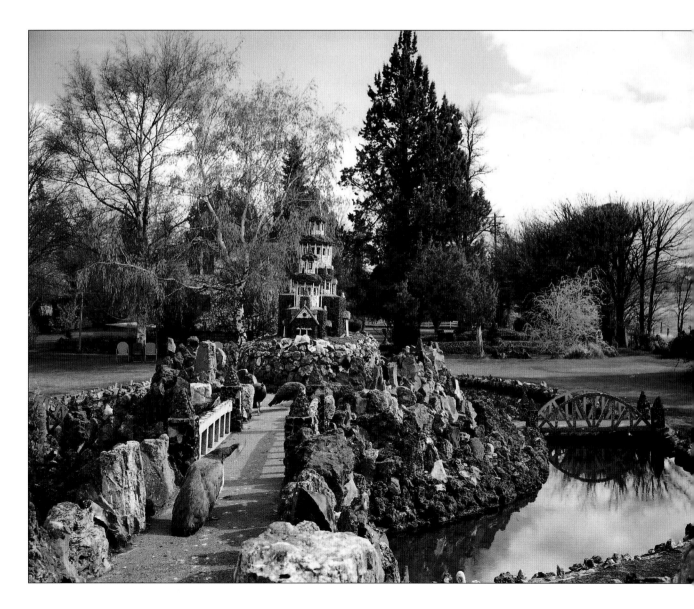

HOUSE AHOY

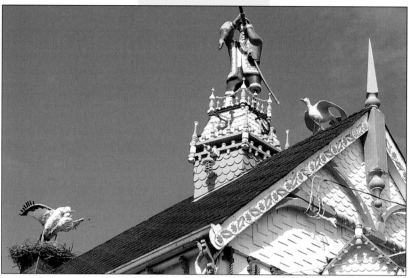

John Keziere
Esquimalt, British Columbia

DOWN AT THE MARINA, NEAR THE ESQUIMALT ARMED FORCES BASE IN VICTORIA, BC, JOHN KEZIERE

AND I ARE HAVING A MOCK TUSSLE OVER THE BREAKFAST BILL. I GRAB HIS ARM, IT BEING ATTACHED

TO THE HAND THAT IS WAVING A STOUT CANE ABOUT MY HEAD, AND IT'S LIKE LAYING HOLD OF

ONE OF THE THOUSANDS OF THICK ROPES KEZIERE HAS SPENT A LIFETIME HAULING ON.

Earlier that morning I saw him bend quickly and gracefully, without puffing or groaning, to retrieve a hammer from the floor of his workshop. Earlier still, at six a.m., he'd been to the pool and done his daily quarter mile.

I guess I can believe that story he'd been telling about singlehandedly bringing a five-masted schooner into Victoria harbour, back in the early days. Born in 1909, John spent more than seventy years at sea on whaling ships and sailing ships, and in the merchant marine. He serves as wharfinger at the government docks, but he spends most of his time working at his house near the water.

It's a house that might have been taken half from an Andrew Wyeth painting and half from a 1920s Out Our Way cartoon: a narrow, white-painted, two-storey building with gold-green trim and a steep pitched roof. And lots of embellishments.

The embellishing started in 1980 when Keziere bought the place, which was covered with asbestos shingles and was, he says, "the ugliest house in Esquimalt." Now there is a life-sized mariner with a spyglass on the roof, gulls and a seahorse on the sides of the house, a clamshell planter under the front window and an anchor under the planter. On the lawn a mermaid rests on pilings and two dolphins leap over the flowerbed near the monkey puzzle tree.

Keziere made most of this stuff himself in his shop, formerly a garage, now remodelled on the outside to look like Davey Jones' locker. The mariner, mermaid, dolphins and seahorse are made of marine fibreglass over welded armatures. What Keziere didn't make, he salvaged. The port and starboard lights mounted on the house came from a ship sunk off Nova Scotia; a ship's wheel and binnacle came from a whaler; the lamp over the porch once hung in the captain's galley of one of the last of the clippers.

On the north side of the house is an expanse of white wall that has vexed Keziere for years. Recently he decided to cover it with a mural of a little fish trying to eat a bigger fish trying to eat an even bigger one. He'll get to it soon. In the meantime, there is a dugout canoe in the driveway that awaits restoring.

Once a month Keziere gets together with his pals,

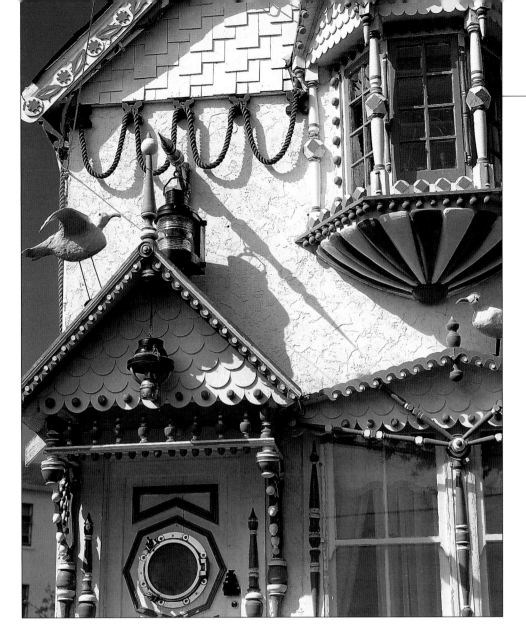

mostly old ships' captains, at the Thermopylae Club, where they swap yarns and plot to preserve the maritime history of the area. But at home, Keziere has created his own monument and repository of marine lore.

Sometimes when he is telling a story, it seems as if the masts are creaking and the thumping of his cane becomes the thudding of a wooden leg. The wind blows across the leaping dolphins and puts out the galley light; whistling round the mermaid, it sounds like a siren's song.

John Keziere (right) worked aboard whaling ships and sailing ships for more than seventy years before he started embellishing his seaside home in 1980. He has created sculptures out of marine fibreglass, salvaged fittings from old ships, and decorated his home and workshop with hundreds of marine artifacts.

THE FUNNY FARM

TO ERR IS HUMAN.
TO FORGIVE....
BOVINE.

Gene Carsey, Jr.
Bend, Oregon

I PHONE THE ONLY CARSEY IN THE BOOK AND GET GENE'S MOTHER. AFTER SHE GIVES ME

ANOTHER NUMBER, I ASK IF HE'S THE GUY WITH THE UNUSUAL PROPERTY. "Y-E-E-E-E-S-S-S," SHE

SIGHS. "I'M AFRAID HE IS."

A few minutes later, Gene Carsey, Jr. is giving me directions on the telephone. "I'm on Highway 97, about six miles north of Bend. You'll know you're here when you see the bowling ball garden." I respond as nonchalantly as possible, as if bowling ball gardens and me go way back. But in the car, I wonder what a bowling ball garden could look like.

It looks like something you might see in the middle of Madagascar, or on some other island ripped from its continental moorings thousands of years ago and, consequently, possessed of its own unique flora and fauna. Bowling balls on posts entwined with vines could be distant cousins to the lacy leafed ouvirandra fenestralis or, at least, the baobab tree. When exposed to sun and rain, as Gene points out, the balls lose their ebony sheen and become pocked and rippled, each one a miniature cratered moon.

Separated from the bowling ball garden are a number of goats. One rolls its eyes, another seems to be on the nod. I say nothing about this, but Gene, a husky fellow in his late forties, rugged but genial, must be reading my mind. "You've heard of epileptic goats? Well, I collect them here. Also any other animals that people don't want or

can't care for, usually because there is something wrong with them. I'll show you some others later but now come and see the Love Pool."

And so I make my first steps into the Funny Farm.

Gene Carsey, Jr. and his partner Mike Craven started out running a secondhand store that offered everything from kitchenware to costumes to antique furniture. They called their place Buffet Flat, in homage to the speakeasies that flourished in black neighbourhoods in the 1920s, and operated it on the other side of the highway until the law shut them down in September 1991. Gene says Buffet Flat was not considered properly conservative. As luck would have it, twenty acres on the east side of the road, directly opposite, was for sale. So they purchased the present site and, in September 1992, officially became a farm. According to local statutes, farms are not covered by certain building restrictions.

The Funny Farm is probably not what the lawmakers had in mind, but it *is* a farm. In addition to the fainting goats there are several mules, some with only one eye, lots of cats, chickens and dogs—including one, a Newfoundland, that I first thought was a black bear. Gene even used to keep ant farms. There are a couple of barns and the kind

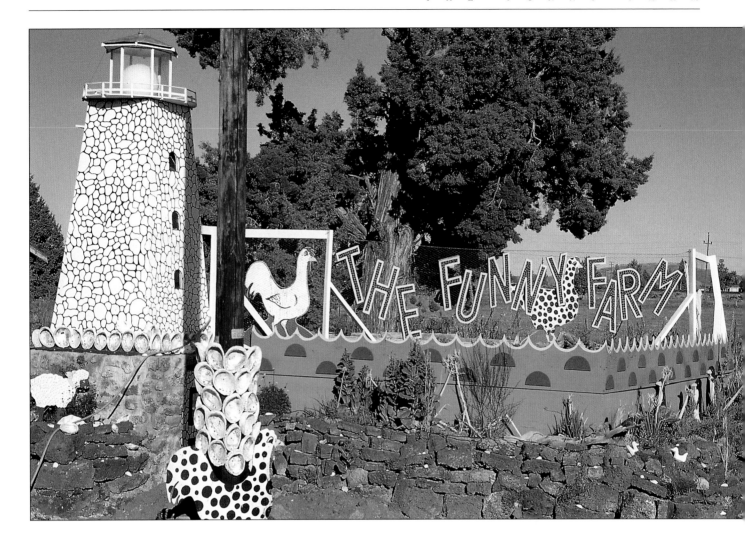

Gene Carsey, Jr. (right) and his partner designated their property a farm so that they could legally embellish it as they wished. Now it is home to an antique store, a bowling ball garden, assorted paintings and sculptures, a menagerie of epileptic goats and other unwanted animals, and one wall covered entirely by washing machine agitators.

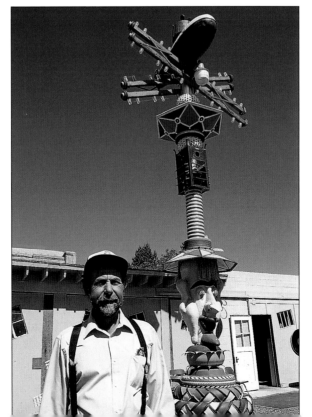

of outbuildings you'd find on any farm. The sec- ondhand business operates in the middle of the farm, and in the middle of the Madagascar-like terrain. There is a bottle tree, a wooden tiger with a saddle, a sculpture of a favourite donkey from the past and a statue called "Three Legged Bowling," fashioned from plaster mannequins and autobody epoxy. Besides its three legs, the bowler has two heads—one that resembles Gene, the other, Mike.

On one wall of the house Gene has painted a twelve-foot-high black lady with yellow blouse and green skirt; her hat is a shelf of plastic fruit. If you peer into her mouth, you're looking into the large end of a telescope that is connected to a small television (tuned to MTV) inside the house.

Gene feeds apples to a little mule that fol- lows us out to the Love Pool, which is valentine- shaped. The bottom and sides of the pool are painted red, and a steel arrow pierces the heart. "Red is the colour for love and passion, right? We'll have marriage ceremonies here, and wed- ding receptions. Every area of the farm will even- tually be divided into sections of colour. There'll be a blue area and a green area, maybe yellow. Like the rainbow. . ."

Looking in the direction he is pointing, I see a rainbow painted across the shingled roof of a barn. "The zoning people were after me about that. They claimed it's distracting to motorists, a traffic hazard."

I feel more than a trifle dizzy walking around the Funny Farm, bombarded by visual oddities, and I admit it to Gene. "Dizzy's okay," he says. "But if you were *agitated* I'd know just the place for you—the Agitator Wall." He shows me the wall of an outbuilding covered entirely by washing machine agitators.

Later I see the black Newfoundland dog go through a trap door on the roof of one outbuild- ing and in a minute emerge on top of another. Gene explains that he has made entire systems of passageways so the dogs and cats can cover acres without running wild and harassing the other animals.

My gaze drops from the dog on the roof to a tin S&H Green Stamps sign nailed to the barn wall, and from there to what looks like a very old and very good folk art painting of three proud strutting roosters.

"How old's that?"

"About six months," says Gene, who even- tually admits he is the artist, and that it is the first painting he ever did. "I didn't know I could paint. Still don't know it. I was just fooling around. Some people liked it, so I've kept on. The roosters are part of a whole series I'm going to do, called Inseparables. These will be about creatures who can't stand to be apart. Roosters or people, they all have buddies. We all have to stick together. Even if they try to break up the combinations and shut you down."

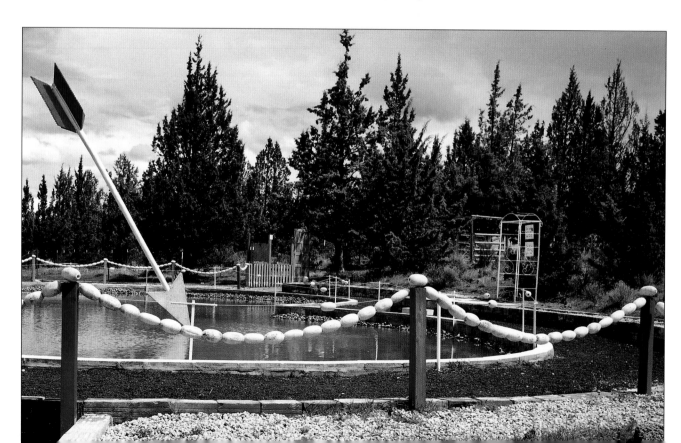

MONUMENT VALLEY

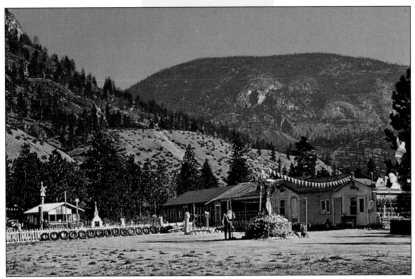

Gottfried Gabriel
Oliver, British Columbia

ON MY FIRST TRIP TO WESTERN CANADA, IN 1970, DRIVING THROUGH THE OKANAGAN VALLEY OF BC,

I SAW, FIRST IN MY PERIPHERAL VISION AND THEN IN MY SIDEVIEW MIRROR, A FLASH OF CHROME AND

COLOURED GLASS, A CLUSTER OF PECULIAR BUILDINGS—AND I'M SURE THERE WAS AN OLD MAN

PUSHING A WHEELBARROW—THE ENTIRE SCENE ENCOMPASSED BY SAGEBRUSH AND DESERT HILLS.

It was an interesting old pack rat, I concluded; part of the montage of the road. I sped on by.

Twenty years later, turning the pages of a book on unusual structures, I stopped at a photograph of an old man pushing a wheelbarrow full of hubcaps and bottles. I knew I had seen him before, and I had. The caption identified him as one Gottfried Gabriel who lived near Oliver, British Columbia. Pictures of his work showed that it spread over a considerable property and included bottle buildings and strange monuments of automobile fenders, motor parts, reflectors, wires, garden ornaments. By this time I was living in Vancouver, just 450 kilometres away, and I was planning a business trip to the Okanagan. I decided to go visit Gabriel and his home.

Oliver is a small town, and Gabriel's work had been featured in a lavish coffee table volume available throughout Europe and North America, so everyone there would of course know all about him, which was fortunate since I had only a couple of hours to spare from my other chores.

The first few people I spoke to didn't know what I was talking about. The editor of the local weekly was aware of the place, but when I asked him whether he'd ever done a piece on Gabriel, he answered, "Why would we have done that?"

Then a woman at the historical society gave me both directions to the property and, alas, the obituary for Gabriel, who died in 1983. She also gave me the only photograph they had—black and white, underexposed, showing another tower, this one topped by what seemed to be a tree welded from metal scraps. It put me in mind of a tree in no man's land in a First World War winter. Other than the death notice, there were no clippings, no pictures, no addresses of relatives, nothing.

It was another year before I returned to the Okanagan and met a Mr. Lehman at Vaseux Lake, who gave me a postcard of his next door neighbour, Gottfried Gabriel, who is shown standing beside one of his towers. He is wearing a black cap, blue work shirt and green pants, and he holds a 40-ounce liquor bottle filled with marbles. He is about a third as tall as the monument, the plinth of

which seems to be made of concrete sprouting bottle bottoms. All this is clothed in chicken wire festooned with bicycle reflectors and other coloured disks. At the base of the tower are stones, some painted, and more headlamps, plastic flowers and living flowers. A four-foot-tall statue of a Roman goddess stands nearby, and more plastic flowers wind round a concrete column supporting the ubiquitous red-capped garden elf—on whose knee sits a plaster statue of John F. Kennedy.

"Junk. All of it junk," said Mr. Lehman. "He work like crazy. Work, work, work. Then he drop dead." We both stared at the postcard. "But you know," added Mr. Lehman, "there were always people coming to see him. And I think the bastard was happy. So who's crazy?"

Gabriel was of Frisian ancestry, born April 13, 1891 in the Ukraine. He was blind in one eye and rejected for military service. Frisians are Celtic in origin, but Gabriel was pronounced German and ordered to work in logging camps in Siberia. He married when the war ended and emigrated to Canada in 1930. Gabriel farmed near Eatonia, Saskatchewan until 1943 when he moved to Oliver with his wife and son, Eric, who supplied me with most of the biographical details about his father.

In the Okanagan, Gabriel would buy a lot, build a cabin and sell for a profit. Later he constructed small houses and sold them. In the early 1960s, he made a fence of bottles and cement around the family bungalow in Oliver. Next he built a bottle garage, and he was at work on a windmill when the city authorities called a halt to his mania. But Gabriel, who was by then obsessed, purchased the five-hectare site near Vaseux Lake, beyond the reach of the building code. Thus in 1966, at the age of seventy-five, Gabriel was able to give full rein to his fantasies. "From then on," says Eric, "he was free and happy."

Eric Gabriel had long since left home by the time his father moved to Vaseux Lake, but from visits he remembers his dad hard at work until the age of ninety, a year before he died. His father made his monuments from bottles, car parts, "musical instruments, statuettes, hot water tanks painted in different colours, and the bar from the old-time gold mining settlement of Fairview."

In the middle of the Vaseux Lake compound was a museum featuring old furniture, farm equipment, riding tack and artifacts donated by the local Indian band chief. Eric reckons there were also 5,000 Christmas tree lights about the place, and when they were all turned on at night the compound glowed like a vast city in the desert. He sent me some photographs of the place and I found a few more. Each picture reveals another corner of the property, another vignette, another piece of a mysterious story. There are windmills, a little church, a giant plywood Santa Claus high in a cottonwood tree, a 150-foot-long house of bottles, and what looks like a miniature railway winding through crushed glass tunnels.

Many far less impressive places in the world have earned their creators notoriety, respect and considerable amounts of money. Gabriel got none of this. He charged no admission, nothing was preserved, and not even the local paper paid him any attention. The book that did mention him, *Fantastic Architecture*, appeared one year after he died.

Gottfried Gabriel's estate was in contention for five years after his death in 1983, and Eric fought to have at least part of the property preserved or donated to the government for protection. But this was not to be, and during the years of dispute, much of the material was stolen and the property often vandalized. Finally the estate was settled and the land was sold. In a note Eric wrote to me, he said, "Have heard that a house is being built and as far as I know nothing remains, only memories."

YUKON BOTTLE HOUSE

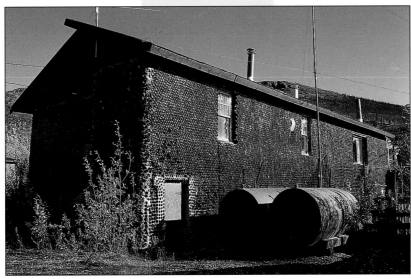

Geordie Dobson
Keno, Yukon

I FIRST CAME UPON GEORDIE DOBSON'S HOME AND SMOKEHOUSE MADE OF BEER BOTTLES BACK IN THE 1970S, WHILE LOOKING FOR WORK IN THE YUKON. UNTIL I HEAR DIFFERENTLY, I'LL MAINTAIN THAT THEY ARE THE NORTHERNMOST BOTTLE BUILDINGS ON THE CONTINENT.

Born in England, Dobson arrived in Canada in 1949 at the age of twenty-four, after spending ten years in the Merchant Marine. In 1950 he went to work for United Keno Hill Mines in Keno, Yukon, and thirteen years later he bought the Keno City Hotel.

Those were the days when anyone who wished to drink beer in the Yukon, or just about anywhere else in Canada, had to do it in a hotel pub. In less self-conscious times, Yukoners prided themselves on drinking more per capita than anyone else in North America. Bottle return policies and official recycling are recent innovations.

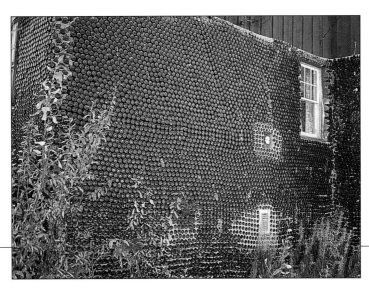

So, from the Gold Rush to the environmentally aware '80s, that's a lot of bottles. Where did they go?

Thirty-two thousand of them went into Dobson's 24 x 60-foot house. "I had finished building it and couldn't decide how to finish the outside," he says.

Staring at the beer bottle mountain out behind the hotel decided for him. "I coated my house with cement and pushed the bottles in neck first. It took me four summers to cover it. The walls are sixteen inches thick and it's a very warm house."

He built the smokehouse with the leftovers.

SCULPTURE GARDEN

George Sawchuk
Fanny Bay, British Columbia

GEORGE SAWCHUK WAS IN HIS SIXTIES WHEN HE HAD A SHOW OF HIS SCULPTURES AT THE VANCOUVER ART GALLERY AND BEGAN TO GAIN INTERNATIONAL RECOGNITION FOR HIS WORK. BEFORE I WENT TO HIS SCULPTURE GARDEN ON VANCOUVER ISLAND, I LOOKED HIM UP IN THE CATALOGUE FOR HIS GALLERY SHOW. IT TOLD ME THAT SAWCHUK "RELIES ON THE WRENCHING OF CONTEXT. HIS WORKS RETAIN OR RESIGNIFY MEANING WITHIN THAT OF THE CONFIGURATION." SAWCHUK DIDN'T WRITE THAT, SO I WASN'T PUT OFF. BUT THE PHOTOS ACCOMPANYING THE PIECE WERE NOT ENCOURAGING. THEY MADE THE SCULPTURES APPEAR CLEAN AND CAREFUL.

Arriving at his place in the village of Fanny Bay, I immediately realize that neither the text nor the photographs do the work justice, and they certainly have not prepared me for the burly character in jeans, long underwear top, red suspenders and cloth cap pulled down to his eyebrows who comes shambling along the driveway to meet me in the rain. Sawchuk's hands are rough and chapped, and seem swollen as if someone had inflated them with an air hose. He has a wooden leg. This is definitely not my idea of an internationally known avant-garde artist. He is more like a bull of the woods, the fellow who'd block your path at some turn-of-the-century logging outfit, anxious to give you a chance to try to knock his block off.

Sawchuk and Pat Heap live in a house he built with a friend. Out the back door is a vegetable garden. This and their chickens provide most of the couple's food. Beyond the vegetable patch, at an opening in the poplar trees, Sawchuk's sculpture garden begins. It occupies a little more than two acres, giving over onto the greenbelt that edges the coves and oyster beds of Fanny Bay. It seems larger, because the path that meanders through has enough turns and twists to have been cleared in the wake of a lost logger with a snootful. But Sawchuk planned it with sober intent, so that visitors would lose their orientation.

Passing through the gate into the garden is like entering a cathedral. It is dark and hushed, particularly on cool and damp winter days. Instead of stained glass

windows, the light filters through the tops of God's own evergreens. And rather than plaster saints, there are monuments perched on tree-stump plinths and reliquaries in trunks. The pieces lurk in thickets and jump out from round corners; they can be glimpsed poking out of the weeds or posing like goofy sentinels at the edges of a slough.

Since those VAG catalogue photographs were taken, Sawchuk's sculptures have been placed in the garden, and shaped and coloured by the weather. The Company Store, for instance, consists of an adding machine inside a roofed shelter mounted on an upright log. In the catalogue photo the work is almost pristine, the machine polished, the store sanded and varnished. But in reality, it is weathered like any wooden structure in the rain forest, and rust has attacked the keys of the adding machine.

On a four-foot-high cedar stump is a black table top that supports a goblet of cherubs; the goblet supports a ball and the ball a proudly erect trophy figure. Everything on the table is painted silver. On another stump, a black hand holds a red apple. A zinc faucet protrudes from one tree, and above the faucet hangs a yellow tin drinking cup. In a square niche cut in a fir tree, one hundred tiny tree rounds are stacked in the background; in front is a stump for a chopping block into which a miniature silver axe has bitten, awaiting a tiny woodcutter.

My favourite is an elongated vertical piece constructed out of bicycle frames and topped by a turned-down black bicycle seat, like a face with two eyes. Picasso might have done it, or one of the African artists who inspired Picasso. When the wind blows, the structure mimics the motion of a rider pedalling vigorously. "I refuse to let the kid be taken out of me," Sawchuk declares.

Whether they are made from the wood around him or assembled from found objects, Sawchuk's sculptures need no explanation. But they often have stories behind them. Out of one tree extends a rack of antlers from which hangs a soggy corduroy coat. The antlers have, over time, come to look like branches of the tree. "That's my tribute to old Shiplap Sam," says Sawchuk. "His real name was Sam Shipsaloff, but we had some Italians on the crew who couldn't pronounce it, so they called him Shiplap Sam. Well, Sam fell on hard times and I let him stay here on the property in a little trailer we had. When he died, I hung up his coat on the antlers."

Sawchuk's Homage to Ginger Goodwin acknowledges a labour hero of the region, a union organizer shot dead by BC Provincial Police in 1918. A more formal piece, the Homage looks at first like a museum exhibit. There is a brass plaque at the base and a glass case on top. Inside the case is a coffin, and inside the coffin, a rifle cartridge—a soft-pointed shell, similar to the one that killed Goodwin. Sawchuk was inspired to do the piece after he came across Goodwin's untended grave in nearby Cumberland, the mining town where Goodwin lived.

Sawchuk cooked perogies and poured an occasional shot of vodka as he talked to me about his life and told some tales. He was born in

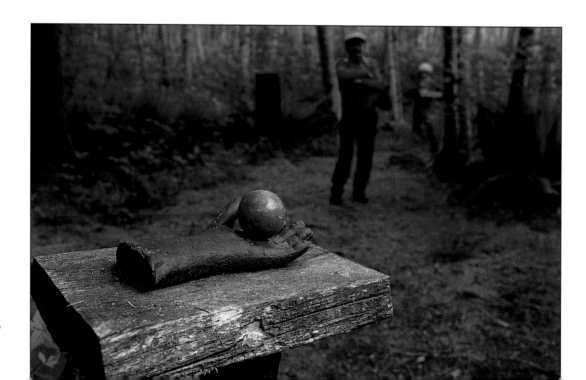

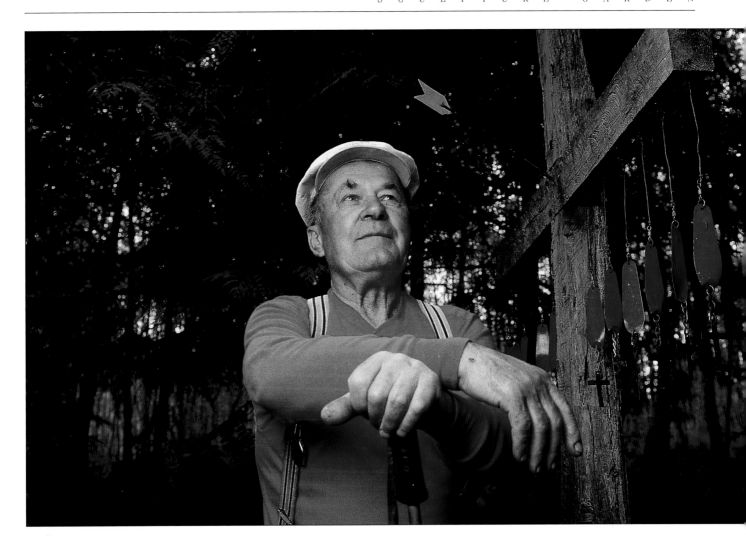

George Sawchuck (above and opposite) hardly fits the image of an internationally known avant-garde artist. His garden of sculptures in the coastal rain forest of Vancouver Island is made from existing trees, carved and painted wood, plumbing fixtures, bicycle frames and rifle cartridges, among other things. His sculptures have been shown in art galleries in Canada and the United States.

Kenora, Ontario of Ukrainian and Polish parents, and through his childhood he studied Marxism and Russian. He was a kid when the Depression struck, and he took to the road "as soon as I was big enough to reach the second rung on the ladder of a boxcar." His education continued on freight trains, aboard ships and in logging camps.

In 1956, when he was working on a Fraser Valley construction project, a load of steel slipped and crushed Sawchuk's leg. Despite his pleas, the doctors refused for twelve years to "buck the Jesus leg off." Sawchuk had to compensate for the injured leg in order to walk all those years, and eventually his spine was affected. Only in 1968 did doctors finally remove the leg. "For the first time since 1956, I was without constant burning pain."

He was living in North Vancouver and getting used to his new wooden leg when he "started making things." First Sawchuk made utensils and built birdhouses. Then he tried carving, and soon was putting the carvings into tree niches. Next he combined them with found objects.

Not unexpectedly, Sawchuk's activities attracted the attention of his neighbours. Those who were most interested turned out to be artists themselves and, even more significant, art curators—Ingrid and Iain Baxter. They told Sawchuk that what he was doing had precedent in art history. "They opened a door in an invisible wall for me."

Success came to Sawchuk quickly, but it arrived uncourted. He has had shows in Canada and the United States, yet he has remained unspoiled by the attention, which borders on celebrity. "I think of the guys I read like Jack London and John Steinbeck, and I vow never to go the way they went and become something I started out opposing."

Art writers have dubbed what Sawchuk does as "yard work" or "site specific installations." When I asked him how he would describe it, Sawchuk shrugged. "I just say I'm going out to the bush to work."

While many of his pieces are made from storm-topped trunks or old stumps, others involve living trees. He has cut niches in these trees, and into them he has placed water faucets, plastic flowers, crucifixes and cans of condensed milk. Sawchuk seems hurt at the suggestion that he would harm a single tree in creating his sculptures. "I would never do such a thing. I'm an ex-logger, and I know trees." He shows me different niches he has cut, pointing out where each original cut was and how the tree is still growing.

Some trees have even grown to the point where they cover the niche. "Eventually all of them will close up with all this stuff inside them," says Sawchuk, "and nobody will be around to know."

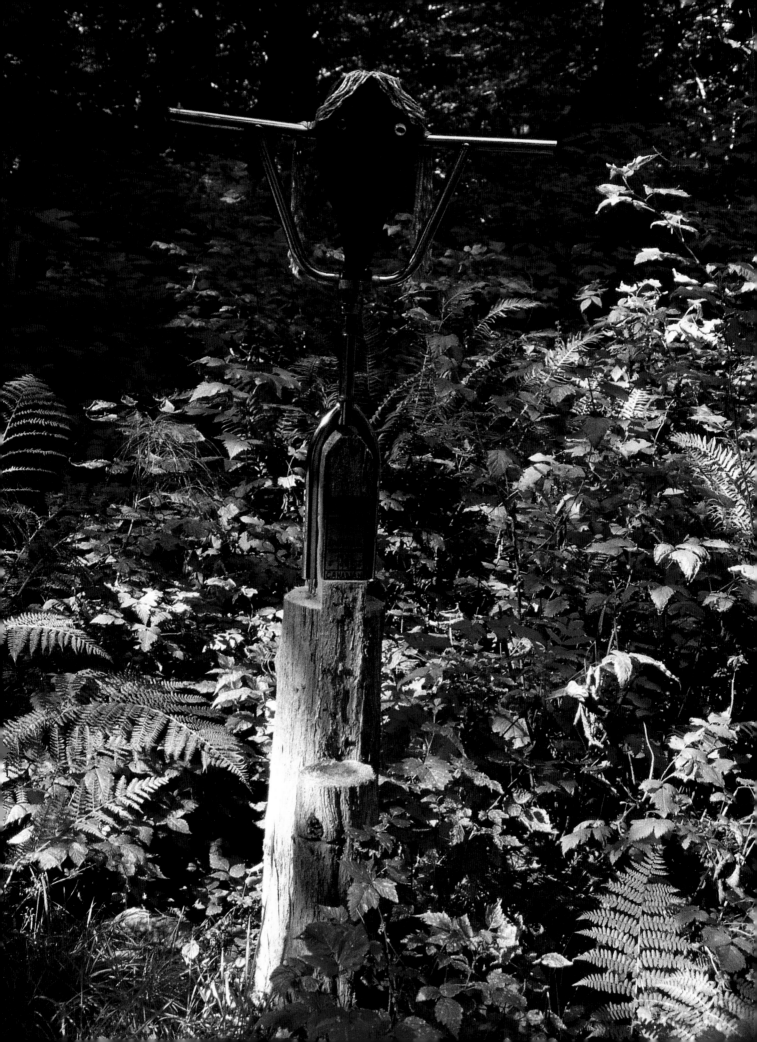

THE FALL OF JE-BUSI

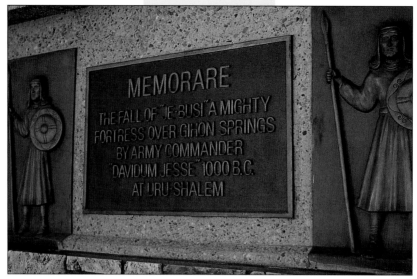

MEMORARE
THE FALL OF "JE-BUSI" A MIGHTY
FORTRESS OVER GIHON SPRINGS
BY ARMY COMMANDER
"DAVIDUM JESSE" 1000 B.C.
AT URU-SHALEM

Earl Browning
Red Deer, Alberta

EARL BROWNING MIGHT NOT WANT TO HEAR IT, BUT WHEN YOU SEE IT FOR THE FIRST TIME, FROM

A DISTANCE, THE WALL HE HAS BUILT AROUND HIS TWO-AND-A-HALF-STOREY APARTMENT BUILD-

ING APPEARS HUMOROUS, EVEN PLAYFUL. WITH ITS MUSHROOM-CAPPED TOWERS AND STONES OF

ALL SIZES SET IN BEDS OF CEMENT, IT COULD BE THE WALL BEHIND WHICH LIVE ALL THE TROLLS OF

ALBERTA, OR MAYBE A RETIREMENT HOME FOR REBELLIOUS LAWN ELVES WHO HAVE ESCAPED THE

MANICURED LAWNS OF SUBURBIA.

On closer inspection, however, the structure gives the impression of order, even harshness. The workmanship is precise, impeccable; each stone is presented in a no-nonsense manner and the spaces between them are swept clean. The mushroom columns are not troll towers but phallic admonitions to go forth and multiply but have no fun doing it.

Laid into the walls at several places are plaques showing soldiers and workers, the largest dedicated to the memory of "The Fall of Je-Busi, a mighty fortress over Gihon Springs by Army Commander Davidum Jess 1000 B.C. at Uru-Shalem."

Someone had come up behind me. "What do you think of it?"

I answered, honestly, "I'm not sure." Then, sensing my mistake, I turned and said, "I mean, I know it's a great unusual work."

He is tall, rawboned and upright. The face is stern, eyes intense. He does not appear pleased by the "unusual" part. As if North America is filled with stone wall monuments to Je-Busi.

"Did you build it?"

He nodded.

I began to ask questions, hoping he would take me through the project from its inception. At first he said nothing, just stared. When I asked why he had built the wall, Browning said, "I'm a Christian."

Then, looking at me fiercely as though he wanted to

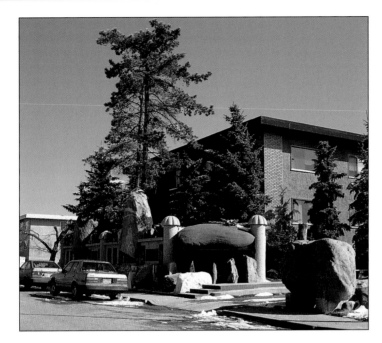

(Left) From a distance, the wall around Earl Browning's apartment building may look like a trolls' rockery, but up close (below), it's clearly no-nonsense rock of ages, built as a monument to biblical soldiers. Plaques are laid into the stone and concrete walls, the largest plaque commemorating "The Fall of Je-Busi, a mighty fortress over Gihon Springs" in 1000 B.C.

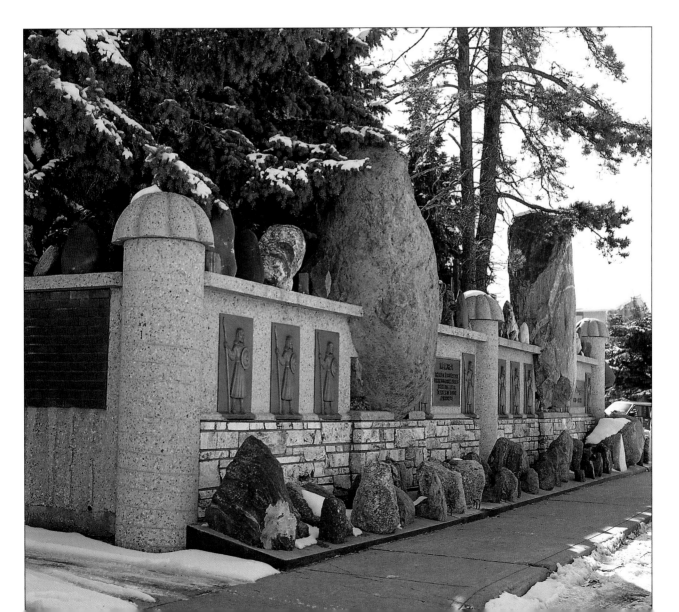

smote me, he said, "What book of the Bible mentions Je-Busi?"

"Let's see . . . near the beginning . . . yes, first book. Genesis."

I may not have been able to cite chapter and verse, but at least I got the book right. Browning became less grim.

He talked about how difficult it was to set the large stones on top of the concrete walls. He had used a crane, but the chain kept slipping. Some of the walls and tables were made of poured concrete, for which Browning built the wooden forms himself. Slivers of wood still cling to the edges.

I tried to get Browning to talk about how and why the idea had come to him, but he refused to elaborate. Instead he suggested I go to the nearby town of Lacombe, to the cemetery where he owned twenty-four plots. Then he stood up and walked away.

Browning has built three monuments in the Lacombe cemetery, concrete tables with stones mounted on the tops. There are plaques bearing scriptures. There is a place for his wife, who left him years ago.

One plaque bears a quotation from John 1:1. "All things were made by Him, without Him was not anything made that was made."

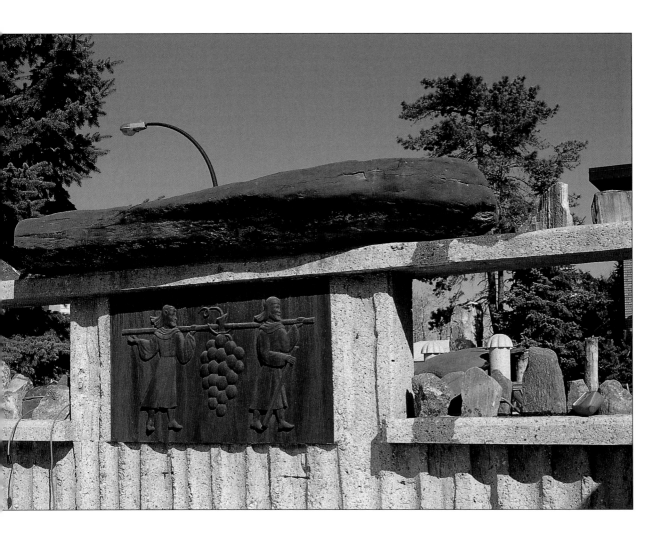

TIMBUCKTEW

Ray Tew
Mission, British Columbia

A FEW YEARS AFTER RAY TEW RETIRED, BACK IN KENORA, HIS HOUSE BURNED DOWN AND HE MOVED WEST. "IT WAS TOO COLD IN THAT COUNTRY TO REBUILD." THAT WAS IN 1990, AND RAY BEGAN IMMEDIATELY TO CHANGE THE APPEARANCE OF HIS HOME AND YARD IN THE FRASER VALLEY TOWN OF MISSION.

"First thing I did was paint the fence yellow, black and white. Then I built the gazebo and the trellises." Then he started doing cartoon characters on the side of the house. They were so popular with the local kids, he drew more figures and added ship and pirate iconography.

Ray had spent years working on boats on Lake Superior and Lake Muskoka. He has a study filled with books on nautical matters, and he collects ship models. Every room of his house is filled with marine lore. He's painted schooners on the doors underneath the sink, and if you open the one on the left you can read the history of the *Mary Celeste*, which Ray has hand-lettered on the inside of the door.

It was only natural that he continue the maritime theme on the outside of his house. The whole place, in fact, looks like some retired pirate's hideaway in the Bahamas. Come to think of it, Ray would look comfortable with a cutlass in his hand and a parrot on his shoulder. But he's a buccaneer with a sense of humour. The sign out front announces: "Timbucktew." And after his old Cadillac Seville had sat out on the lawn for a while with a price on the windshield and no buyers, Ray accepted it as part of his yard display.

In 1993, he fell off a ladder in the yard and broke his neck. I met him when he was just learning to manoeuvre with an aluminum walker, and he was eager to get back to work. A couple of years later, he is perfectly capable of climbing up onto the roof to install a combination lighthouse–birdhouse.

Ray has other projects in mind, such as replacing his large wheel of fortune, which generates enough electricity to power its own lights. The wheel was the object of teenaged vandals, so Ray bought a guard dog named Eli with a no-nonsense growl. Once Eli is done making noise, he is very affectionate. It is not clear to me whether the dog was like that to begin with, or whether living at Timbucktew made him change.

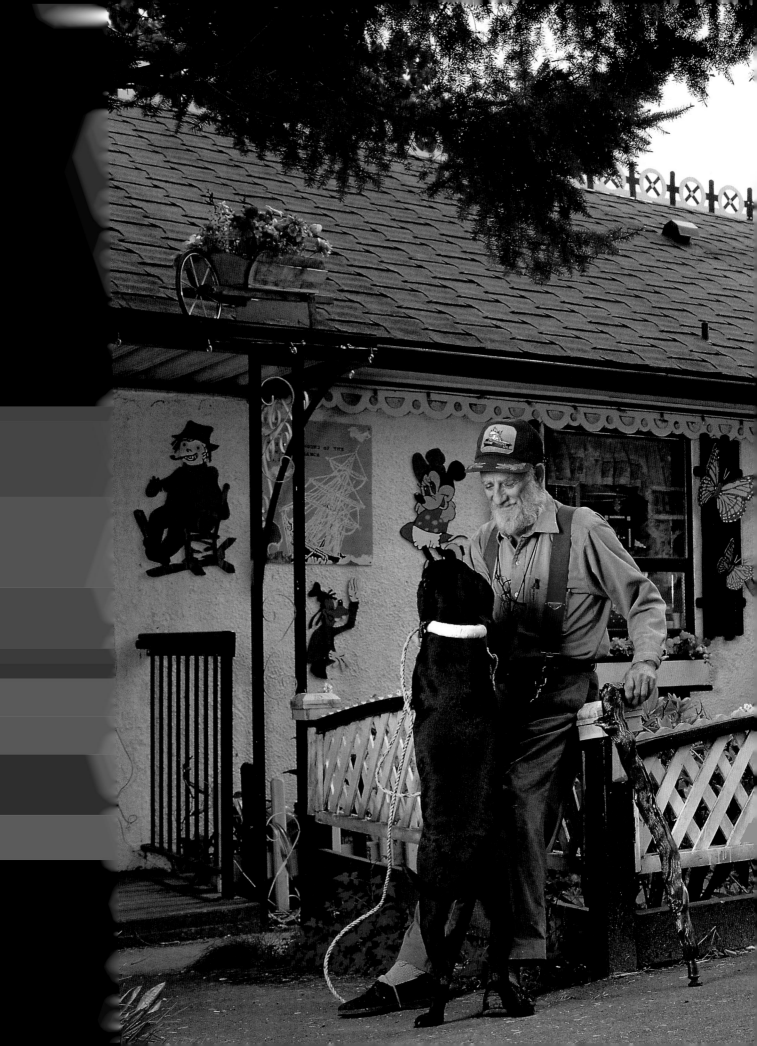

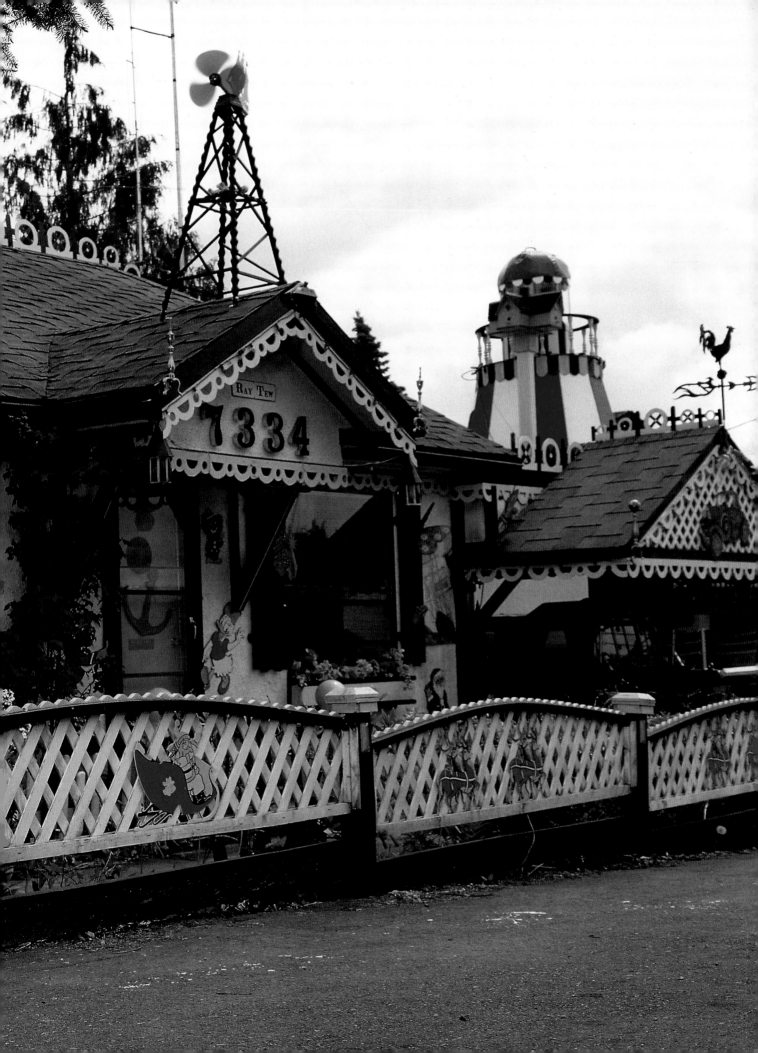

GARDEN OF THE WIND

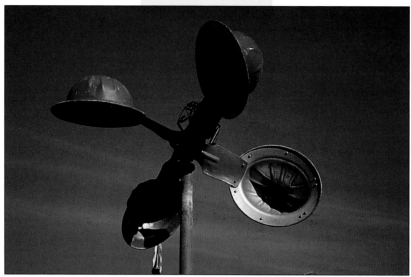

Emil and Veva Gehrke
Grand Coulee, Washington

EMIL GEHRKE LIVED A FORTUNATE LIFE THAT LASTED NINETY-FOUR YEARS. HE WAS WELL LIKED, EARNED A GOOD LIVING, HAD A FINE MARRIAGE WITH VEVA, AND ACHIEVED A MEASURE OF PLEASING ATTENTION WITH THE HOBBY THAT OCCUPIED HIM DURING HIS RETIREMENT YEARS. GEHRKE MADE WINDMILLS, AND PEOPLE FROM ALL OVER THE WORLD CAME TO SEE THEM AT THE GEHRKE HOME IN GRAND COULEE, WASHINGTON.

Gehrke constructed six hundred of them from the junk he and Veva collected on their long foraging trips by automobile. He used bicycle wheels, waffle irons, oven racks, plastic cups, baking dishes, hubcaps, serving trays, buckets, funnels, soup spoons, teapots, sea shells, tin cans, sandbox shovels, coffee percolators and hard hats. Many are decorated with cherubs, baby dolls and figures welded from pipe joints. Emil made them all, and Veva painted them.

Born in Nebraska, Gehrke worked his way west and laboured in lumber mills and box factories for many years. A skilled mechanic, carpenter and millwright, he was the person who repaired the machinery when it broke down, and he was expected to use his ingenuity to see that it didn't happen again.

The Gehrkes moved to Grand Coulee after Emil retired in the late 1950s, and he began to prove himself a man ahead of his time. Having been long disturbed by the amount of usable stuff that is discarded, Gehrke took up his hobby—not because he aspired to be a craftsman, but "to show that practically any object can be reused."

He selected material from a garage filled with junk waiting to be transformed, and assembled the first windmill in his basement. As he told an interviewer from the local historical society, "Balancing is the secret, so you have to do it in a place where there is no wind."

After he had made the first few windmills, Gehrke put them in his back yard, painted some old washer tubs and planted flowers—and the visitors popped up immediately. They came from as far away as Israel and Japan, and many of them bought windmills to take home. Still, at any one time there were as many as 308 windmills in the back yard. And Gehrke went on building them until his death in 1984.

In the 1970s, Gehrke had his picture in *National Geographic* and *Sunset* magazines, and he was filmed by both CBS and ABC. Fame ended there, but fortune continued to bless his work. First Seattle City Light bought twenty-

seven windmills for its Viewlands–Hoffman sub-station. Then more than a hundred citizens of Grand Coulee purchased windmills and proposed that the city donate part of the North Dam Bicentennial Park for a permanent display of Gehrke's creations. Astoundingly, the powers-that-be in this small community comprehended the unique accomplishments of Emil Gehrke— independent, far-sighted and resourceful, a man straight out of the American myth—and agreed. Now visitors who have negotiated the steep, winding road, oohing and aahing at the massive

public works project that is the famous dam, can visit the other side of town and marvel at the achievement of one extraordinary artist.

The Gehrke windmill garden is a discon-certing sight. Over a hundred windmills stand in a small space, surrounded by a high metal fence. From one of the hills across the road, it looks like a collection of unfathomable monuments, maybe part Celtic and part Plains Indian. Up close, the garden is like a holding cell for eccentricity, each inmate waiting for a wind to set it free, to stretch its limbs, to whirl and whistle.

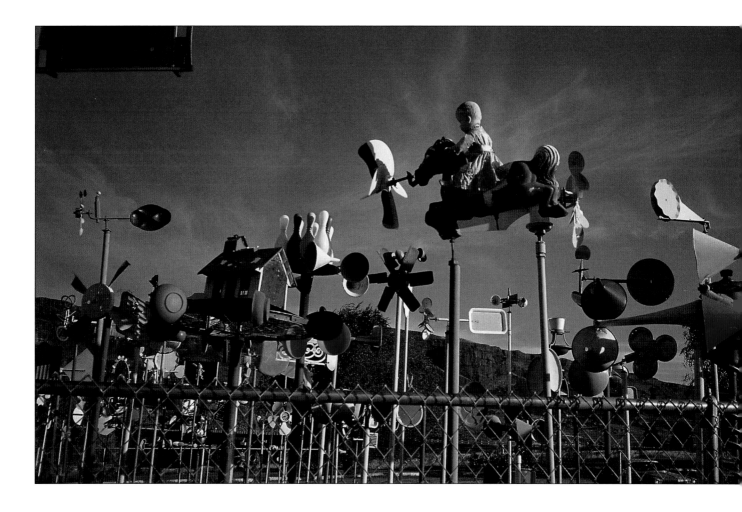

In the late 1950s, long before recycling came into vogue, Emil and Veva Gehrke were rescuing discarded toys, hard hats, teapots, oven racks, bicycle wheels and lots of other stuff, and making it into windmills (above). Emil wasn't aspiring to be a craftsman, he just wanted "to show that practically any object can be reused."

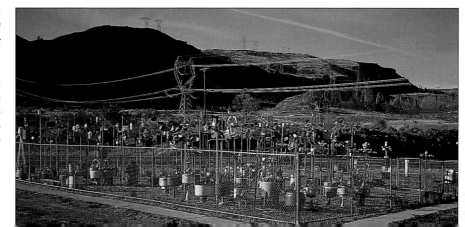

JERRY'S EYRIE

Jerry McKinnon
Wallace, Idaho

MINING FORTUNES WERE MADE AROUND WALLACE, IDAHO, AND MUCH OF THE WEALTH WAS CONVERTED INTO MAGNIFICENT EDWARDIAN STONE BUILDINGS. A LOT OF TIME AND THOUGHT HAS GONE INTO PRESENTING WALLACE TO TOURISTS. THE CITY HAS SUCCESSFULLY ATTRACTED VISITORS WITHOUT DEGRADING ITSELF BY TURNING INTO A THEME PARK.

It is therefore ironic, and in some circles must be galling, that the most impressive structure in town—and the most popular on the tourist circuit—is a rickety wooden joint with spaceships on its roof, perched on a jungly hillside and surrounded by giant paintings on plywood of Goofy, the Seven Dwarfs, Donald Duck, Santa Claus and an assortment of angels.

This is all the doing of Jerry McKinnon—who, had I believed an article in a Spokane newspaper that comprises his entire publicity, I would never even have approached. The article describes him as a recluse, a weird hermit, sullenly uncommunicative if cornered.

His friend Don Grebil, who with his wife Jeanne operates an RV park below Jerry's place, assures me this is nonsense. Acting as intermediary, Don shouts to Jerry in his eyrie and Jerry hoots back. They are like two yodellers calling from alp to alp. Don has told me Jerry is in his early sixties, so when a trim, athletic figure dances gracefully down more than fifty slippery wooden steps, his head bobbing above Goofy and Daffy, I figure it must be a neighbour.

But no, it is indeed Jerry, who turns out to be a sweet, shy man, but certainly not unfriendly. He has lived in his home since the late 1970s, when he began to draw pictures by copying them from colouring books. With no plan in mind, Jerry was soon working on large pieces of plywood which he set out on the steep slope that amounts to his front yard.

He gets food money from recycling tin cans, which he collects on three-in-the-morning explorations of the dumpsters of Wallace. During early foragings, Jerry became interested in certain bits of junk, like pieces of tin and chunks of plastic. He carted all of this home and eventually used it to make his strange rooftop sculptures. "You see that one moves in the wind. That one there is stationary and I can sit inside it and look out through those little windows."

In the stream at the foot of the hill, Jerry rigged a paddle wheel that runs the radio in his kitchen, and the revolving spaceship on the roof generates more electricity. "He's a bit of a genius in his way," says Don. "He could probably make anything he had a notion to."

The paintings are very accomplished, but Jerry doesn't

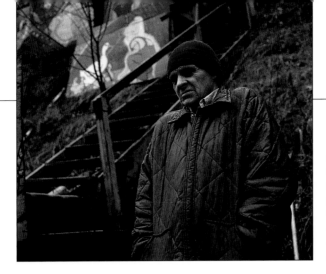

(Left) Jerry McKinnon has just danced down fifty slippery steps from his eyrie, a rickety wooden joint with spaceships on the roof and giant paintings of Santa, Goofy, Daffy Duck all around. One of the spaceships generates electricity as it revolves, and in a nearby stream Jerry has rigged up a paddle wheel that runs the radio in his kitchen.

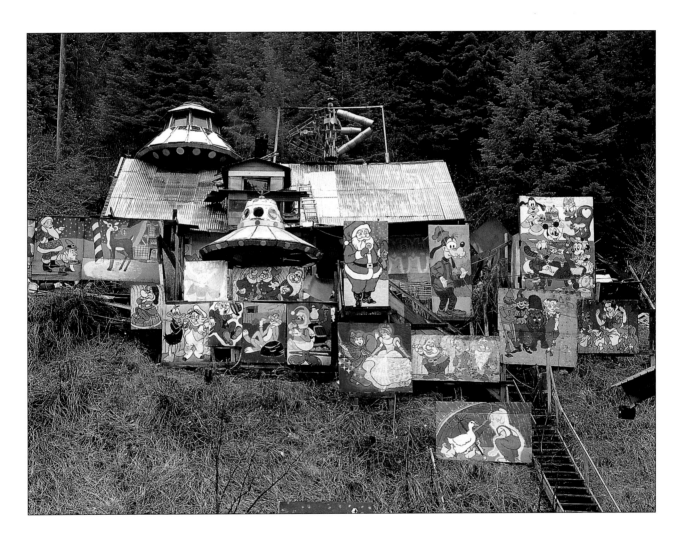

have much to say about them. "I see them in my mind and have to make them," he shrugs. What he does want to talk about, and seems most proud of, is his unique lassoing trick. "You want to see?"

Jerry hustles over to set up his target, a pole with concrete-filled pails at either end. Then, standing thirty-five or forty feet away, with his back to the target, Jerry twirls a length of electrical cable over his head and lets fly. After a warmup, he lassos the pole nine out of ten times without looking.

Don asks him to stop for a while ("He can stay there doing that for hours"), and Jerry comes over to say goodbye. We all shake hands, and I ask him what he's going to do tonight.

"I'm doing Elmer Fudd."

As I drive off, I get a last glimpse of Jerry dancing nimbly up the steps.

WALKER ROCK GARDEN

Milton Walker
West Seattle, Washington

SEATTLE HAS BEEN FILLED WITH BOEING WORKERS FOR A LONG TIME, AND MILTON WALKER WAS ONE OF THEM. LIKE MANY OF THE MEN WHO WORKED THERE, HE HAD A WIFE, A KID, A HOUSE, AND THAT WAS HIS LIFE. THEN CAME THE LONG, FAMOUS STRIKE OF 1948. AFTER A COUPLE OF WEEKS OF IT, MILTON WAS BORED OUT OF HIS MIND.

He had no hobbies and he didn't drink. He started clearing the brush on the slope in back of the house on 37th Avenue S.W., but that didn't take long. He and his wife Florence took to driving around in the car for hours, and one day, just over the state line in Oregon, they came upon a going-out-of-business sale at a rock shop. Piles and piles of coloured rocks were heaped in front of the place and they looked pretty.

"We stopped and bought them all," Florence Walker remembers. "We paid $150, which I thought was too much. Later I learned they were worth at least ten times that. I often wondered why the lady sold them to us so cheap. Then, not too long ago, a visitor here said, 'It was because you were meant to have them.'" Milton and Florence loaded the truck, and went back pulling a trailer. It took ten return trips to haul away the rocks.

Milton's first project was to put a magnificent stone facade on the brick oven in the back yard, which the Walkers used for cookouts. "He had a bucket with cement," says Florence. "He'd put down a bit, then a stone, then another bit and a stone."

It is a beautiful job, worthy of an accomplished mason with an artistic bent. But Walker had only tried cement work once, five years earlier. The results are still there at the side of the house, a sort of rock and mortar border to the walkway. The mortar is slobbery and it overwhelms the stones, an example of what masons refer to as "rice pudding." There is no explaining the contrast. Florence maintains that her husband never referred to a masonry text, an art book or a work on architecture.

The brick oven was completed, the strike ended and Walker went back to the Boeing routine. It would be another ten years before he did any more work in his garden. Then he made a little mountain and lake display. Over the next couple of years, he did other "lakes," or pools. There was another decade-long hiatus and from this, Walker miraculously emerged as an artist. He started setting stones in interesting patterns and arranging colours in unexpected ways. This phase began with the laying of a floor around the brick oven. "He set the stones out in a design on a picnic table," Florence says. "Next he poured the cement down and I handed him the stones one by one."

Walker's creative work of the late 1960s brought him his first publicity, an article in a lapidary journal. Soon rock hounds from all over the world were visiting the garden in West Seattle. Encouraged by the attention, and recently retired from the plant, Walker devoted most of his time to the garden, adding big displays but always concentrating on the smallest details. There is a huge tower and small walkway blocks, each of these produced by the indirect method in a wooden form. Walker would make a frame, set his stones face down and pour in the concrete. There are hundreds of these blocks, some with abstract designs, others showing butterflies. Walker must have loved butterflies. They are all over the place, especially in a tall monument called the Swing Wall. Here there are also mosaics featuring birds and wine goblets.

Walker's greatest individual work is the Centennial Tower, a graceful accumulation of architectural forms all encrusted with crystals, pebbles, geodes and tiny chunks of glass. It is dazzling in the rare Seattle sunshine.

Milton died in 1984, and Florence is getting too old to take care of the garden, although she enjoys talking to visitors. Fortunately there have been so many appreciative guests that some have been inspired to establish the Friends of the Walker Rock Garden, dedicated to maintaining and preserving this truly incredible display.

Milton Walker had never worked with concrete or stones before he and his wife bought the entire inventory of an out-of-business Oregon rock shop. His first project was a facade for an outdoor brick oven, and he just kept going. The displays are big, but Walker's attention to detail was meticulous—the Bicentennial Tower (right) and some of the butterflies in the Crystal Wall (opposite) are examples.

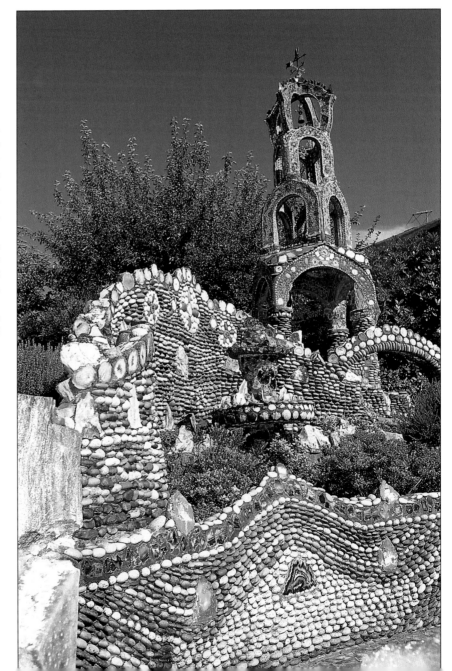

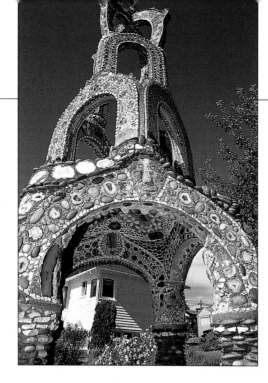

Walker's creations, encrusted with crystals, pebbles, geodes, figurines and tiny chunks of glass, are dazzling in the rare Seattle sunshine.

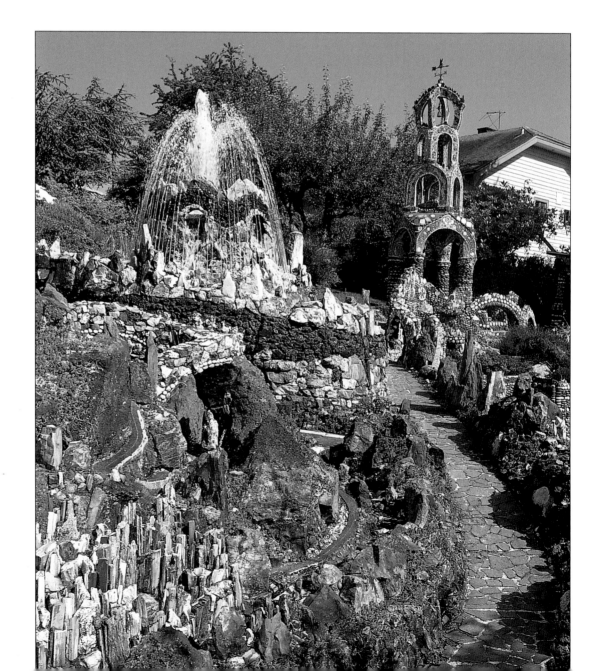

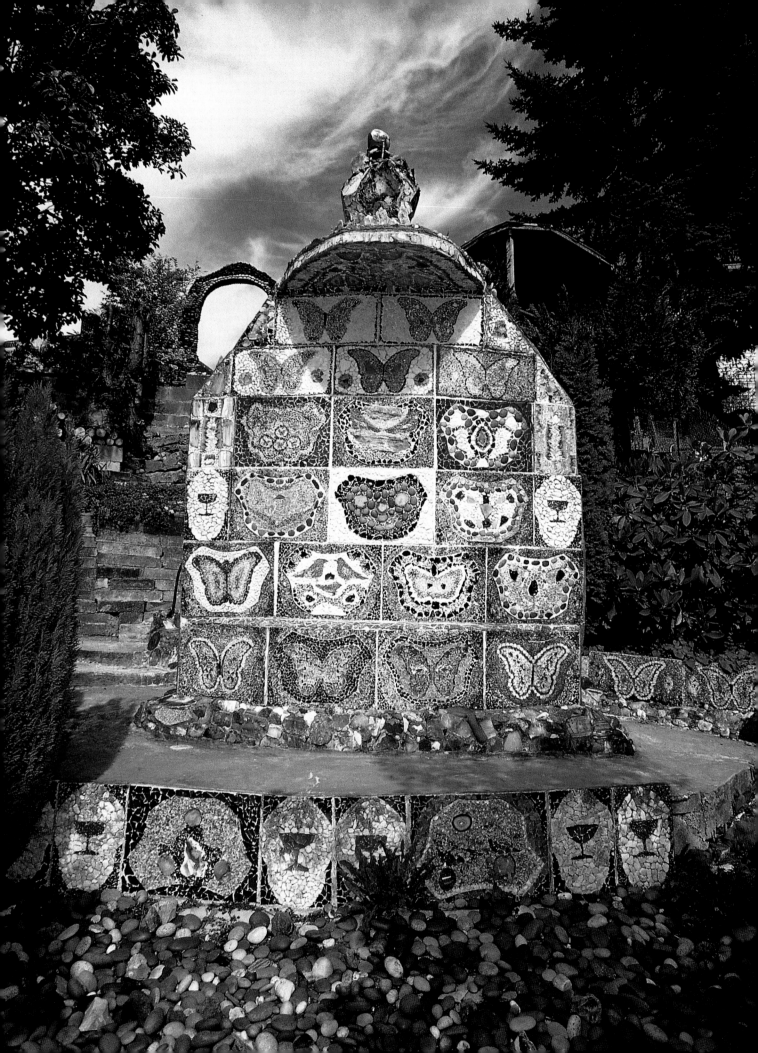

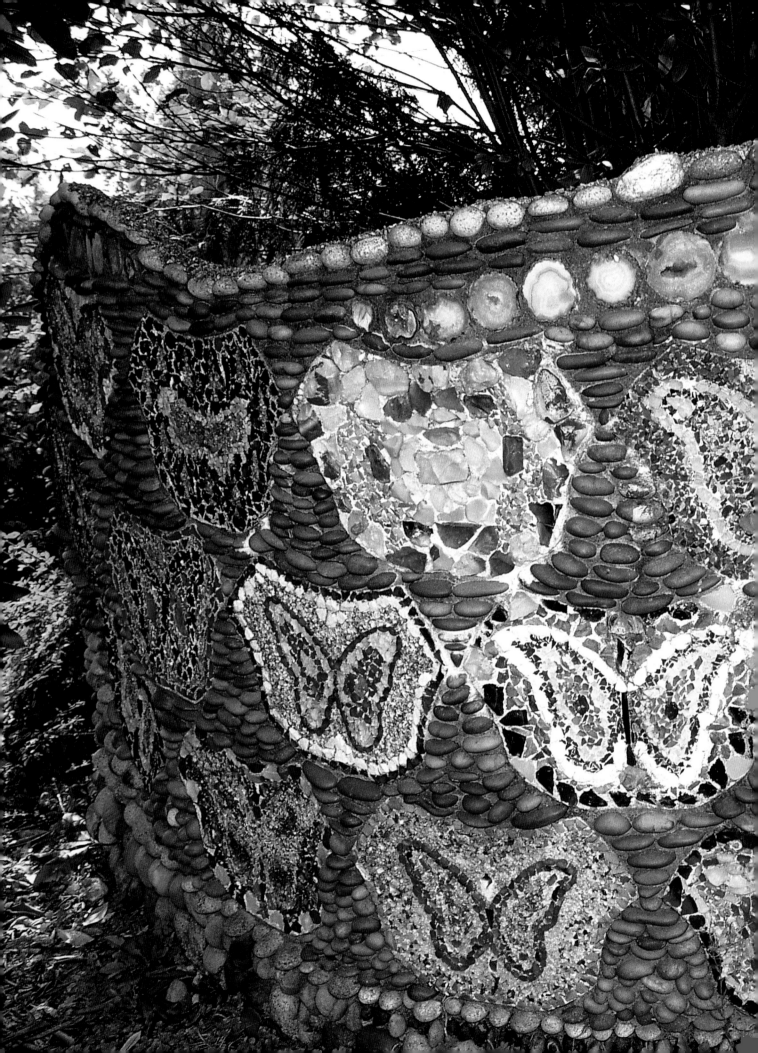

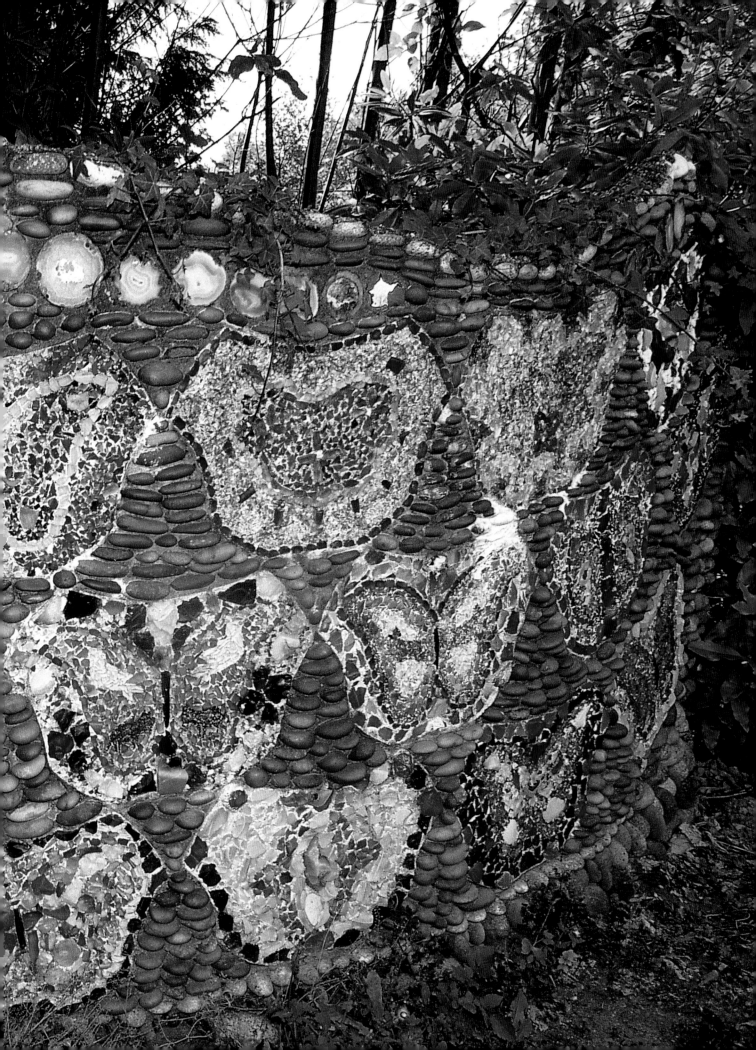

THE MINING LIFE

Dominic Job
Missoula, Montana

A FEW DECADES AGO, WHEN DOMINIC JOB WAS WORKING AS A CAT MECHANIC, HE NOTICED THAT

HIS CUSTOMERS WHO WERE INVOLVED WITH MINING MADE A LOT MORE MONEY THAN HE DID, BUT

WERE NOT ONE BIT SMARTER. "SO I BEGAN TO MAKE A STUDY OF MINING. I READ ABOUT

GEOLOGY, EVERYTHING HAVING TO DO WITH MINING."

Soon he was buying and exploiting mine properties, something he does to this day. His interests have taken him from Mexico to the Northwest Territories. Dominic also developed an interest in the life and culture of working mines, claims and prospectors' camps. Eventually, at his home in Missoula, he started to re-create aspects of that life. He began the project in 1970, hauling obsidian and quartz rock from the family farm in North Dakota. Eventually he shipped more than 600 tons of stone.

There's the Winchester mine tunnel with a rail car emerging, filled with rock, and across the yard is the bigger Black Diamond mine. There is a jail, even an outhouse. Each display is like a short story, an excerpt of the mining life. Dominic has also installed statues of miners, many of them Italian or Mexican. They worked hard, drank a little wine, and prayed to the Virgin Mary, whom Dominic has put in her niche, a pebbled cowl; the reliquary is mounted on slabs of travertine marble. Dominic's most impressive construction is a rockery in the form of a mountain, in which a prospector pans for gold at a creek flowing from a hidden pump.

There are also subtle details such as the concrete mosaics embedded in the sidewalk. One is a crossed pick and spade; the other, in the shape of the state of Montana, bears the names of Dominic and his deceased wife, Theresa.

Dominic Job's fascination with the life and culture of working mines inspired him to create displays that replicate and honour the mining life.

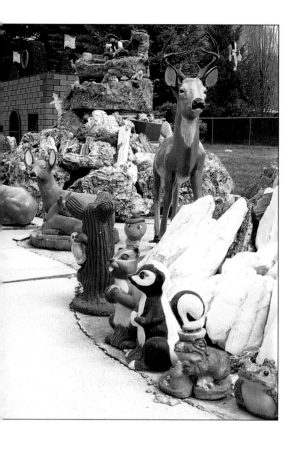

Job (below) began his yard work in 1970, hauling obsidian and quartz rock (left) from the family farm in North Dakota. "Eventually," he says, "I shipped more than 600 tons."

CONTINUING CELEBRATION

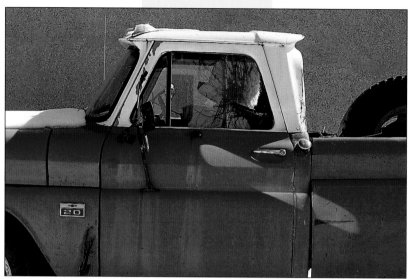

Lowrie Streatch
Red Deer, Alberta

HE DRIVES AROUND IN AN OLD VALIANT, ITS ONCE-RED PAINT FADED TO DUSTY ROSE, TIRES SINK-ING, SEATS FILLED WITH HIS PARTNERS—DOZENS OF STUFFED ANIMALS. HE HAS KIND EYES THAT TURN DOWN AT THE CORNERS, PINK SKIN AND WISPS OF WHITE HAIR, AND HE'S NOT VERY TALL. WEARING A BASEBALL CAP, THE BRIM JUST PEEKING OVER THE STEERING WHEEL, HE COULD BE THE COACH OUT WITH HIS TEAM. AT HOME HE SHUFFLES AROUND THE YARD IN OLD GREY AND BLACK CHECKERED SLIPPERS. HIS NAME FITS LIKE THE SLIPPERS: HE'S LOWRIE STREATCH.

His yard is a permanent display, and the inside of his house makes a Victorian bric-a-brac living room seem austere.

Several years ago in the gloom of an Alberta winter, Lowrie thought about how nice yards in his Red Deer neighbourhood had looked at Christmas with the lights and crèches, Santa and his reindeer, and he decided there should be more of that good feeling a Christmas display inspires. Ground Hog Day was coming up, and Lowrie determined it should have its own celebration. But after he created it, he couldn't bring himself to take it down. He began right away to work on a display for Valentine's Day. After February 14 there was work to do for Easter, Queen Victoria's birthday, Canada Day, Labour Day, and on it went. There were still plenty of gaps, but these Lowrie filled with his newly liberated imagination.

For instance, when I first visited in mid-September, the long weeks between Labour Day and Thanksgiving had been given over to Grandma and Grandpa Skunk's fiftieth wedding anniversary. There were refreshments, music, even a skunk cocktail waitress. Dozens of skunks had been cut from plywood and tin, but the honoured guests were stuffed and perched in captain's chairs. They had stripes down their backs, but otherwise resembled a couple of aging blues singers.

On the other side of the driveway beyond a tall hedge, a toy tractor pulls three kids' wagons filled with flowers, a bed sits on a real farm wagon, toy animals pedal bicycles. There are horse-and-wagon whirligigs on poles alongside multi-level birdhouses and stuffed horses in the back yard, and calliope horses in the storage shed—a build-ing that is more like a roofed adjunct to the yard. Onto the

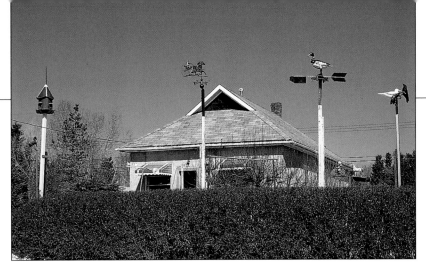

Lowrie Streatch's home and yard are a permanent celebration of every imaginable holiday, including Christmas, Ground Hog Day, Queen Victoria's birthday, and the golden wedding anniversary of Grandma and Grandpa Skunk. (Below) What Lowrie insists is his dining room.

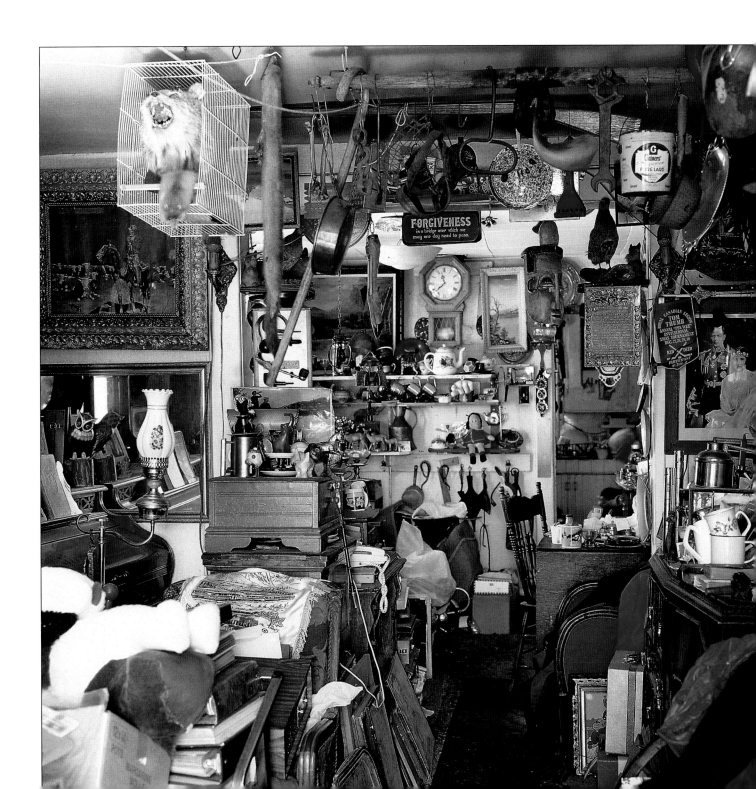

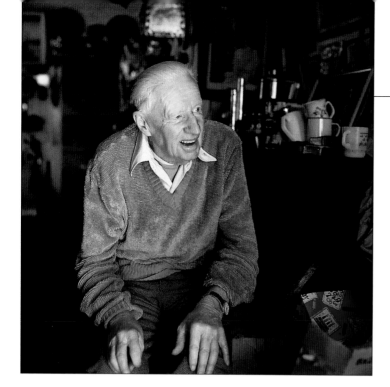

Streatch (left and opposite) made most of the displays in his yard, and those he didn't make, he scavenged. He's still collecting things—even the dead station wagon in the driveway is crammed with stuffed animals.

sides Lowrie has nailed plywood horse heads and a pair of plywood cows. The two windows resemble Joseph Cornell boxes: their contents have a random look yet also seem harmonious.

There is also a pickup truck and a dead station wagon in the driveway, each holding more stuffed animals; he's got other handmade figures out in the garden patch, and more flowers, some in pots on a row of folding school chairs, some in miniature greenhouses. He's painted homilies on boards attached to the sides of buildings, put plastic owls in birdcages, created a creature who looks like a cross between a space raider and Pancho Villa.

Lowrie made most of it; the rest he scavenged. Thousands of objects. I suppose stuffed lynx are not the rarest of items, nor dried bats, but you don't come across bronzed purple martens every day. He has a collection of antique instruments, including a 150-year-old organ. Much of the sheet music was nostalgia-inspiring when Lowrie was just starting out. Table tops, shelves and bookcases are filled with bronze figurines; pictures of horses crowd the walls. On and on, outside the house and in.

Holding up a dill pickle jar filled with pellets, Lowrie says, "Got these from a porcupine. I was walking in the park late one night. I saw the porcupine and what he was doing. Looked like some kind of record so I scooped them up into the jar."

"You just happened to be carrying a big jar with you?"

"Of course."

I try to picture it, three in the morning, an insomniac neighbour watching from over the way.

"Guess how many."

"One hundred seventy-seven."

"Two hundred twelve. I took the jar around to all the old age homes and held a contest."

He produces another jar, a five-quart affair, holding what looks like the remains of Gabriel Dumont's famous buffalo coat, but is in fact a truly elephantine dropping. "Was at the circus," Lowrie smiles in remembrance. "Got it while it was still rolling." He shows me several necklaces he's fashioned from llama pellets, with bead spacers.

Lowrie has an album with photos of his late wife's gravesite, and another album with pictures of other interesting graves. Near the front door is an altar to their son, who was a young hockey player when he was killed driving to a game in 1964. "The weather report warned that the roads were icy and dangerous. We urged him not to go…"

Lowrie quickly changes the subject, shows me more stuff and asks me back real soon. Then, standing among the skunks, he tugs at the brim of his cap, peeks out from under it and waves goodbye.

RICHART'S RUINS

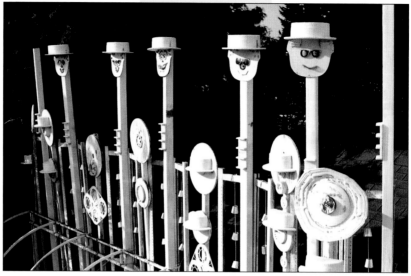

Dick Tracy / RICHART
Centralia, Washington

COMING UPON RICHART'S PLACE, I THINK ABOUT THOSE OLD EXPLORERS ENCOUNTERING ANCIENT RUINS IN LATIN AMERICA OR ASIA FOR THE FIRST TIME. THEY'D LEFT EUROPEAN CITIES WHICH THEY ASSUMED WERE THE APEX OF CIVILIZATION, TO SEARCH FOR SOMETHING THAT WAS PERHAPS INTERESTING, BUT DEFINITELY INFERIOR—AND THERE THEY WERE EMERGING FROM THE JUNGLE FOR THE FIRST GLIMPSE OF CHICHÉN ITZÁ OR ANGKOR WAT.

They would have been amazed, but humbled too, if they had any sense. After those unnerving first impressions wore off, the explorers were going to have to rearrange their notion of civilization.

I exit the Interstate and struggle though the franchise jungle of Centralia, Washington. I know from half a block away that I have found RICHART's continually expanding ruins. Spires that can only be compared to poles or pikes rise high above a thick cedar hedge, the tips lost in the branches of trees. I can easily imagine silent warriors holding the standards of this little civilization. I wouldn't be at all surprised if drums began to beat, startled birds to call and the poles to shake in rhythm.

There are several entrances to this unique terrain, each like a bending trail revealing curiosities and wonders. The trails themselves recall jungle images, because many are covered like igarapes. Wood and styrofoam are the predominant materials of the land so far. But you are amazed to find wood assembled and stacked this way, to see styrofoam looking as permanent as stone. The wood becomes the pikes and other tall standing structures best designated as "things." The styrofoam, straight out of packing crates, is glued, painted, sometimes coated in floor wax or varnish, fashioned to resemble codices carved into Mayan temple walls. In fact, the whole place has a centuries-old, Palenque–Piranesi look, with a touch of Flash Gordon here and there.

The man responsible is officially named Dick Tracy, but "official" becomes meaningless once you enter his realm. He is "Rich in Art," a name that suits him. Tanned, grey-haired, wearing a golf shirt and bermuda shorts, he waits in one of the igarapes wondering, as he later tells me, how far to allow visitors to penetrate his kingdom.

Anything and everything goes into his mix: old shoes, washtubs, flower pots, plenty of hoses and brushes. Recently he has taken up welding. "I'm getting old, they

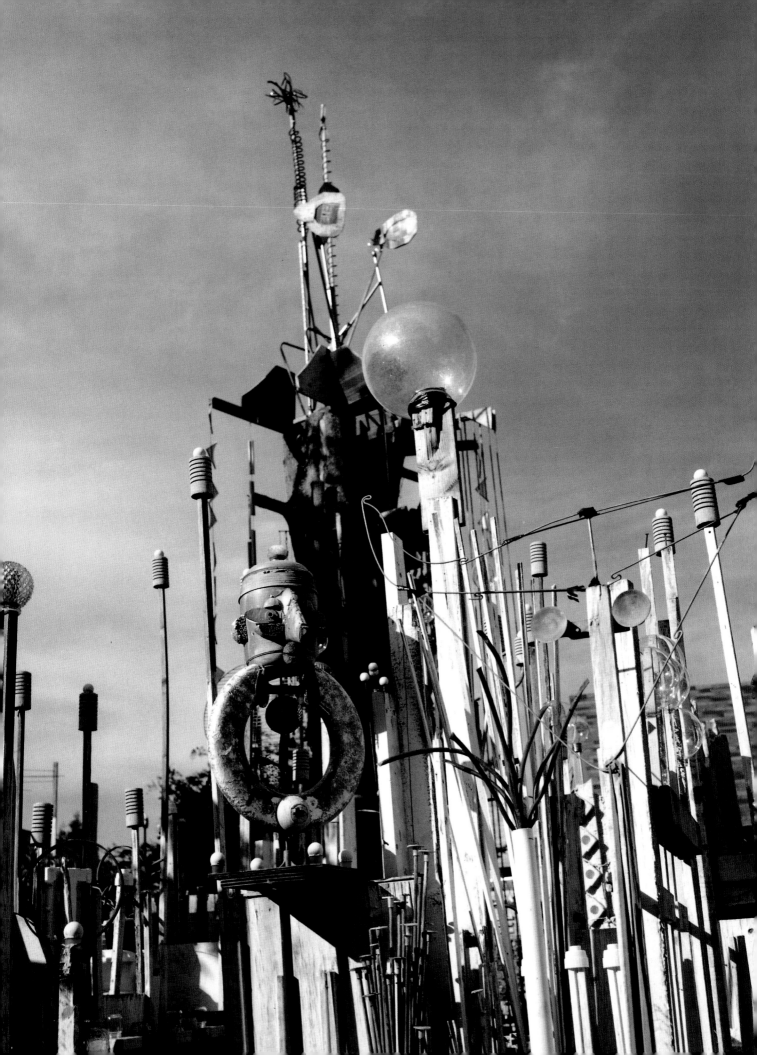

tell me. And technically I'm unemployed even though I have my private art students. The authorities gave me a choice for retraining, and I chose welding. I didn't do this because I wanted a job, but so I could weld art. It's a good thing I don't want a welding job, because I'm at the bottom of my class. That's good for me because my sloppy beads have character. I can always depend on my welding to be bad, but I raid the waste cans for other students' rejected bits. At the beginning, their work was bad too, so I'd take it. Now they've gotten good. Naturally I can't explain any of this to them."

He proudly displays some of his bad welding, transformed into good art. These are small abstract pieces; around back in another part of the jungle, he's begun to weld large creatures.

Rich operates his place as a sort of fall-by art school. Curious passersby are invited to take a five- or fifteen- or twenty-minute class during which they use materials at hand to make art. Years ago, he taught in a more traditional manner.

"I have lots of degrees which I've surmounted."

His home used to be thoroughly traditional, like those of his neighbours. One afternoon he had a student coming over. Rich waited and waited. He had a bag of styrofoam coffee cups left over from a gathering, and as he waited, he began gluing the cups to the pillars that supported what was recognizable then as a carport. The student never showed up, and Rich kept on going. That was fourteen years ago and he doesn't intend to stop.

His place never stops either, or doesn't seem to, because there are so many trails, byways, nooks, crannies, niches and hideouts. He has a hideout of his own that he calls his "confessional." It overlooks the main street. "I sit there and listen to what people say about my place. If I like what I hear, I'll raise the blinds and exclaim, *That's right!*"

Many people brave enough to enter the kingdom ask him if he makes a living from his art. "No," he tells them, "but I live for my art."

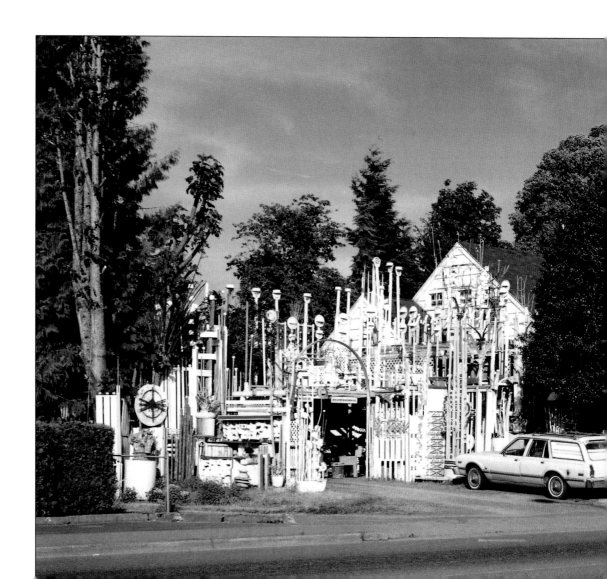

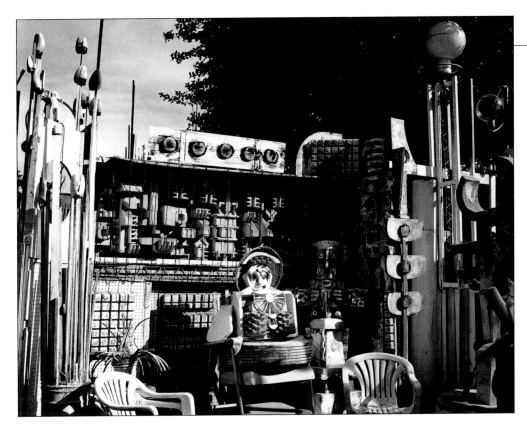

Not too long ago, *RICHART's Ruins* looked like every other place on the street. Then *RICHART* (below), officially named *Dick Tracy*, started erecting tall pikes, gluing and varnishing chunks of styrofoam packing, and assembling improbable stacks of wood and junk. The result is a unique terrain that looks centuries old, with a touch of Flash Gordon.

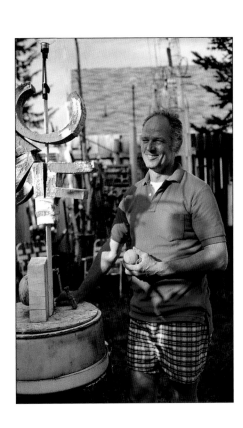

Out On The Margins

All of the sites in this book are bizarre, yet they are as different from each other as the people who created them. If they have something in common, it is that when you come upon one, you are immediately enchanted by its raw, spontaneous eloquence. Most of the places in *Strange Sites* were created by people who would never think of themselves as professional artists, but their work mirrors the trends and materials of other contemporary art. In fact, the work is more powerful for the creators' unconcern about any of that, and it is available to everyone, including those who find modern architecture and most gallery art to be vacuous or insufferably self-indulgent.

What is the future for these sorts of creations, those already in existence and others yet to be envisioned and put together? More and more attention is being paid to strange homes and gardens, which can only improve their chances of being maintained and protected. But three factors militate against the creation of future outlandish environments. First, the people who can do this kind of work are aging and dying. Second, land prices are too high for most artisans to buy enough room to work. Third, building codes, supposedly designed to ensure that structures are safe and durable, also restrict building materials and practices to the point where any creative deviation becomes illegal.

Almost all of the creators featured here grew up making and fixing things with their hands. They could repair the tractor, build the house, take apart the pump and put it together again, and keep the pickup going with baling wire. So if they became obsessed by the preposterous idea of making a castle of junk or a home from bottles, well, just roll up the sleeves and get at her. Few people in succeeding generations have the skills or the inclination to assemble homes and yards like these. Only three sites—Dick and Jane's Spot, the Funny Farm and Little Mansion were created by people under the age of sixty. All of the builders were born in small towns and rural communities before the technological revolution, and some grew up in remote spots where even the industrial revolution had yet to make its full impact. They reached adulthood when it was still not unusual in North America for a man to make a good living with his hands and for a couple to raise a family in their own house on their own land. If they desired to make a weird and wonderful eye-popping traffic-stopping attraction of their home or garden, they could go about it without incurring the wrath of their neighbours or local zoning officials.

There are certainly still people with multifarious manual skills, and a few more to come. A number of these folks will attempt something in the skylarking, personalized environment line. But they're going to have to do it farther and farther away from centres that are ever expanding. Then, as now, they will be working not in the vanguard or behind the times, but out on the margins—literally, as well as figuratively.

Still, it is impossible to stamp out eccentricity or artistically bizarre behaviour. There will always be free spirits to defy the neighbours, the trends, and the powers-that-be. Their work may become less visible, but it will continue to inspire the rest of us. I count myself lucky to have travelled through the northwest finding uncommon homes and gardens, to have received all these revivifying slaps on the back and jolts to the sensibilities. And I have not seen nearly all of the area's strange sites. These and others I do not yet know about are out there, unsung yet singing. The voices may be a little off-key at times but they are joyous nonetheless. They sing the song of, "Yoo hoo! It's me. I am alive!"

(Opposite) House Ahoy and its creator, John Keziere, who says it was once "the ugliest house in Esquimalt."